'I captured the purest and most pleasing images of Nature; that Nature which is always my teacher'

ANTONI GAUDÍ

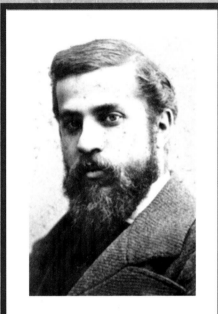

CHAUCER PRESS

First published
in Great Britain by
CHAUCER PRESS
an imprint of the
Caxton Publishing Group Ltd
20 Bloomsbury Street
London WC1B 3JH
This edition copyright
© 2004 Chaucer Press
Derek Avery has asserted
his right to be identified
as the author of this work in
accordance with the
Copyright, Designs and Patents Act
1988
Unless otherwise credited, all of the
photographs in this publication
have been supplied by courtesy of
Aldino™

ISBN 1 904449 10 7

A copy of the CIP data for this
book is available from the
British Library upon request
Prepared and designed for
Chaucer Press
by Superlaunch Limited, PO Box 207
Abingdon OX13 6TA
Imagesetting by
International Graphic Services, Bath
Printed and bound in China

CONTENTS

AN ARCHITECT OF DEVOTION 6

EARLY BUILDINGS 26

CASA VICENS 30

THE SAGRADA FAMILIA 38

CASA EL CAPRICHO 54

GÜELL ESTATE 58

PALAU GÜELL 66

PALAU EPISCOPAL 78

COLEGIO DE LAS TERESIANAS 82

CASA DE LOS BOTINES 88

THE GÜELL BODEGAS 90

CASA CALVET 92

GÜELL COLONY CRYPT 98

BELLESGUARD 102

PARC GÜELL 112

FINCA MIRALLES 128

PALMA CATHEDRAL 132

CASA BATLLÓ 134

CASA MILÀ 144

SAGRADA FAMILIA PARISH SCHOOL 154

INDEX 156

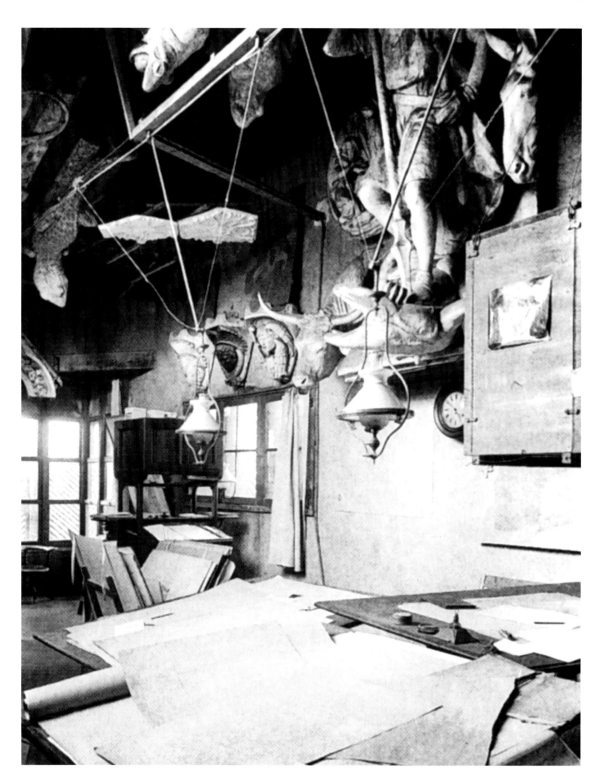

AN ARCHITECT OF DEVOTION

ANTONI GAUDÍ WAS THE FIFTH and last child of Francesc Gaudí, a coppersmith from Riudoms, and Antònia Cornet, who was also from a family of coppersmiths established in Reus. None of his four elder siblings were long-lived and indeed he himself had suffered from rheumatic fever while very young.

He was born on 25 June 1852 at 4 Carrer de Sant Joan, Reus, in a house that was demolished a hundred years ago, and on the day after his birth he was baptised Anton Placito (or Plàcid) Guillem, at the parish church of St Peter the Apostle in Reus.

At that time Reus was the second largest city in Catalonia, an industrial centre with a population of about 27,000 people; it was famous chiefly for the spinning of cotton and silk. Its other principal industry was the distillation of *aguardiente*, a term often used to include any spirituous liquor such as brandy.

Following his primary education, Gaudí started work, seven days a week, as a bellows-boy. He worked

Left: *Gaudí established a workshop in the Sagrada Familia, into which he shut himself for many hours at a time. It was known to Walter Gropius and, following a visit to Barcelona soon after the First World War, was described by Ernst Neufert, one of his architect students, as follows: 'I saw there the ideal architect's workshop that Gropius had spoken of so much in the romantic beginnings of the Bauhaus. There was the authentic Bauhütte (the hut of the medieval mason), the cabin built on the firm foundations of faith, which I would not have found in any other place on the planet! It made a profound impression on me, and I felt the desire to talk to Gaudí.'*

the bellows that provided the draught for the fire beneath the steam boiler in a cotton yarn and fabrics factory called the Vapor Nou (New Steam) company.

Both the works' owner, Joan Tarrats, and Francesc, Gaudí's elder and only surviving brother, encouraged him to study; at the age of eleven the young Antoni entered the Escoles Pies (church schools) that were run by the monks in Reus. Here his education included not only the apostolic Roman Catholic faith, but introductions to the elements of geometry, mechanics and the natural sciences. All of these influences were to remain with him throughout his working life, and may be seen not only in his finished works, but also in the methods that he used.

On 19 September 1868, having attended the school for five years, he was on the point of applying for his final year when General Prim, a native of Reus, led an uprising against the Spanish monarchy. Many of the factories in Reus were burnt down in consequence, before a revolutionary council took charge of the town. This council proclaimed the dissolution of all religious orders, and so the monks of the Escoles Pies fled their monastery and abandoned the city.

This upheaval meant that Antoni Gaudí, who was recorded as neither diligent nor a brilliant pupil, had to complete his schooling in Barcelona, where he obtained his leaving certificate from an institute of secondary education. He stayed to find work in Barcelona which was then a city of about 300,000 inhabitants, despite the recent outbreaks of cholera and yellow fever, epidemics that had ravaged the area.

The work that he wanted was intended to help in his preparations to qualify as a master builder, as architects were then described. By the time he reached the age of twenty-one, although not gifted in the art, he was employed in a workshop as a draughtsman. The job enabled him to pay for his studies, to gain experience and to help to feed his parents, who were then living with him and his elder brother in Barcelona. However, it also meant that his studies at the school of

Below: a drawing of Barcelona made in 1868, the year in which Gaudí went to that city in order to complete his education

Below: Gaudí submitted this plan for a cemetery gate to the academy as part of his examination paper on drafting, in 1875

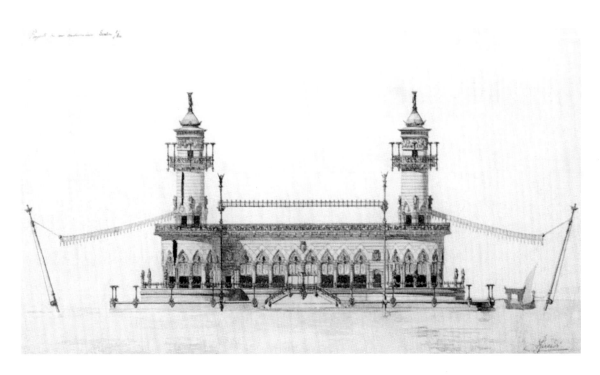

architecture did not always receive his full attention, and therefore he did not attain the coveted title for another five years, when he was twenty-six.

Initial commissions for the newly-qualified architect were varied and diverse, and quite soon he had gained a reputation for himself as a man of talent. The experience of working alongside carpenters, blacksmiths, potters and glaziers that Gaudí had gained in the workshops of the sculptor Llorenç Mutamala and that of Eudald Puntí undoubtedly contributed significantly to this perception, and again provided him with a source of inspiration that lasted his whole life.

His first commission for a new building was awarded to him by a wealthy weaver, Salvador Pagés, who was originally from his home town of Reus. Pagés had moved to Barcelona, where he was prominent in the cooperative of mechanical weavers, although it is unclear whether his fortune had been made there, or during the few years that he had spent in New York.

Pagés had become the general manager of the Cooperativa Obrera Mataronense by 1869. This factory

Above: a student drawing, elevation and front view, by Gaudí, 1876. This design for a Royal Wharf did not win for Gaudí the special prize that he had hoped it would

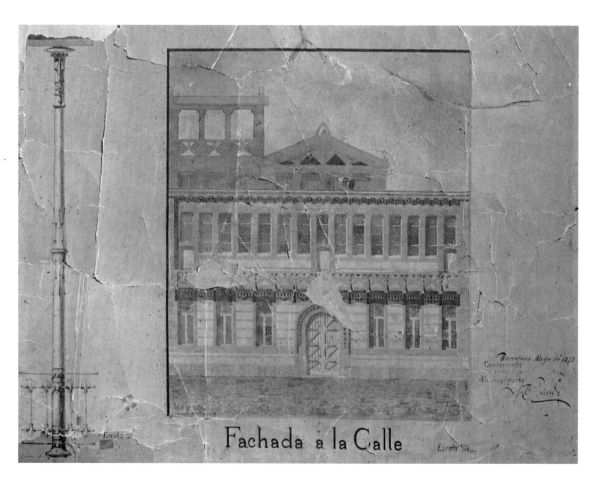

Fachada a la Calle

was established in the town of Mataró, some 30km (20 miles) north of Barcelona, and where Pagés planned to build a group of detached houses for the workers.

The Gaudí plan, for which the construction agreement for the first house was signed on 29 March 1878, was for the provision of 30 detached houses. Each of these was to be 12 x 9 metres (39.4 x 29.5ft) square and to stand in its own plot of approximately 200m² (2,150sq ft). The house would consist of a ground floor plus a basement, with the façade topped by a triangular pediment. The houses were to be laid out in three rows near the sea, and in such a way that they would receive sunlight both in the morning and in the afternoon, but would be sheltered from the prevailing winds. Unfortunately the cooperative went into decline and

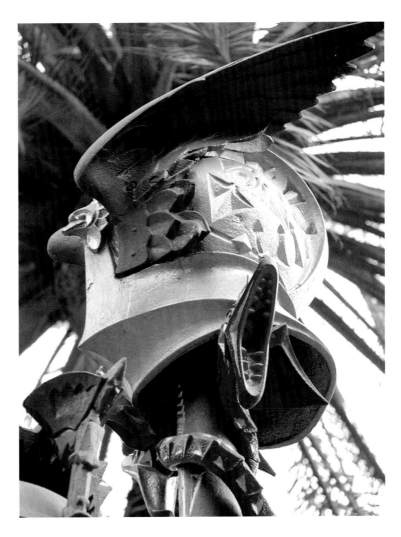

Left: a draft plan by Gaudí, 1873, for the street-side façade of houses for the Mataró workers' cooperative. On the left of the façade is a design for an iron column, that was planned for the rear balconies that would overlook the houses' garden. Unfortunately the initiative failed, even after the directors of the cooperative suggested that the members could build the houses on their own account, provided that they followed Gaudí's plans. Only two houses were ever built, one of which was for the general manager of La Obrera Mataronense, Salvador Pagés

Below left: commissions of this period included one from the city of Barcelona in February 1878, for the design of street lamps for the Plaça Reial. On the **left** is a front view of the top of the central column which holds six lights, and **above right** is a side view. The lamps, which were completed during the following year, are in cast iron and stone, and frame the central fountain of the Three Graces

by the time that it eventually went into liquidation in 1887, a mere two houses had been built.

Meanwhile, Gaudí had been commissioned to design an apartment building by Manuel Vicens i Montaner, in 1878. Although Gaudí's life in Barcelona appeared to be improving as he gained commissions and his circle of friends widened, his one known proposal of marriage was rejected. Josefa Moreu i Fornells was the daughter of a wealthy family from Mataró, but following this rejection, her suitor continued to live with his father.

His last remaining sibling, Rosa, the first child to have been born to their parents, died in 1879. She

left behind an orphaned girl who was then three years old. The child was also named Rosa but was referred to affectionately by Gaudí as Rosita, and he enrolled her in a nuns' school. This was something that the young architect was now well able to afford; indeed, by this time deprivation was a thing of the past for Gaudí. The confidence that financial security brings enables us to express our deepest beliefs, and Gaudí was no different in this respect. He had been an ardent Catalanist since his student days, and he continued to associate with men who shared his interests and had similar ideologies.

Among his student associates were the architect Josep Fontseré (1829–87), and his brother Eduard Fontseré i Mestre. The latter was not only also an architect, but, more importantly to Gaudí, the president of the Masonic Lealtad (loyalty) lodge, a secret Catalan society. Camil Oliveras was another of Gaudí's contemporaries and yet another architect; together with Gaudí, he belonged to the Catalanist Association of Scientific Excursions. This society encompassed, among other things, an interest in the protection of old buildings and other works that its members considered to be of historical Catalan interest. One of the founders of this

Below: a photograph of members of the Catalanist Association of Scientific Excursions (the excursionists) taken in 1883 in the cloisters of the cathedral at Etna. The photograph shows Gaudí (circled, fourth from right) together with J Verdaguer, N Oller and A Guimerà

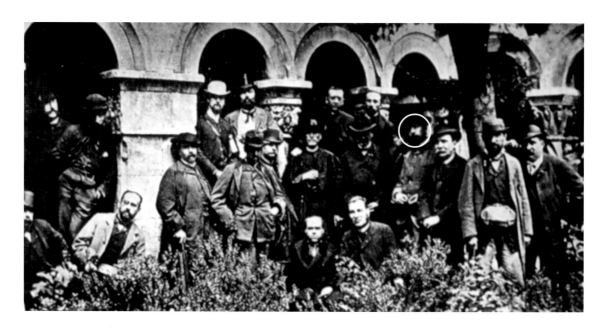

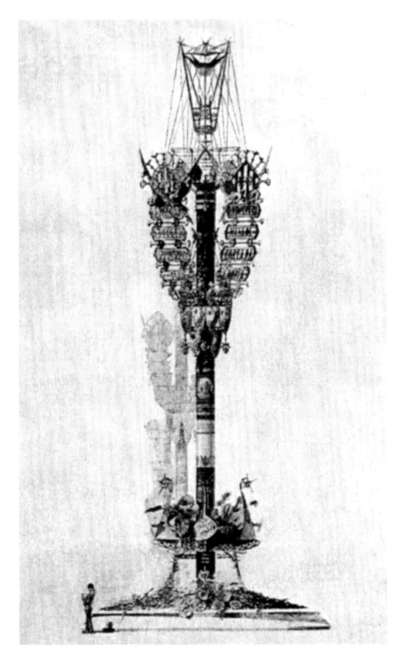

Left: *Gaudí designed these huge street lights in 1880 for the promenade on the Passeig de Muralla del Mar in Barcelona, in a demonstration of his Catalan loyalties. They were to bear the names of prominent Catalonian admirals, but the project was never realised*

Association had been Eudald Canibell i Masbernat. This native of Barcelona was an artist, typographer and writer who shared Gaudí's interest in artistic and scientific naturalism. This they both regarded as a means of regenerating and modernising Catalan society.

Right: the Sagrada Familia is still under construction, more than a hundred years after Antoni Gaudí first took charge of the project in 1883. This view shows the western façade of the Passion, on the side opposite the Nativity. This was begun in 1956, thirty years after the death of Gaudí, and is decorated with sculptures by Josep Maria Subirachs

Through associates such as these, Gaudí was drawn to the Café Pelai, a meeting place for intellectuals and artists in the Catalan capital. It had become truly an institution that was known throughout Catalonia where, it was recorded in 1884 by the exiled Russian Jewish writer Issac Iakovlevich Pavlovski,

'... every working day at two o'clock in the afternoon, winter or summer, the Catalanists begin to arrive at the Café Pelai, where they gather round a table in a room overlooking the Rambla and Carrer Pelai...'.

Another architect with whom Gaudí had considerable contact and who was to play a major part in his future was Joan Martorell i Montells. He was twenty years Gaudí's senior, and they had first met when Gaudí worked as his assistant. Martorell was the architect who first taught Gaudí to solve by geometrical means the problems of equilibrium that are of primary importance in construction. Even more importantly, it was he who would later introduce Gaudí to the man who would be his great benefactor, and a lifelong friend.

Eusebi Güell i Bacigalupi (1846−1918) was the heir to a sizeable fortune. His father, Joan Güell, had emigrated at the age of eighteen to Cuba, which at that time was a Spanish colony. Eventually he established a virtual monopoly over the the liquor market in Havana, but returned to Catalonia in 1835. At once he proceded to invest his acquired fortune by buying factory after factory, while at the same time pursuing a political career. He became first a municipal councillor for Barcelona, then a member of Parliament, and eventually a Senator. During this campaign he had managed also to acquire his own architect, Joan Martorell.

Meanwhile his son, Eusebi Güell, had married Isabel López. She was the daughter of Antonio López López, who had also emigrated to Cuba and likewise made his fortune, but in his case primarily through dealings in the African slave market. On his return to Spain, López founded companies and banks, bought mines and railways, and in the small mining village of

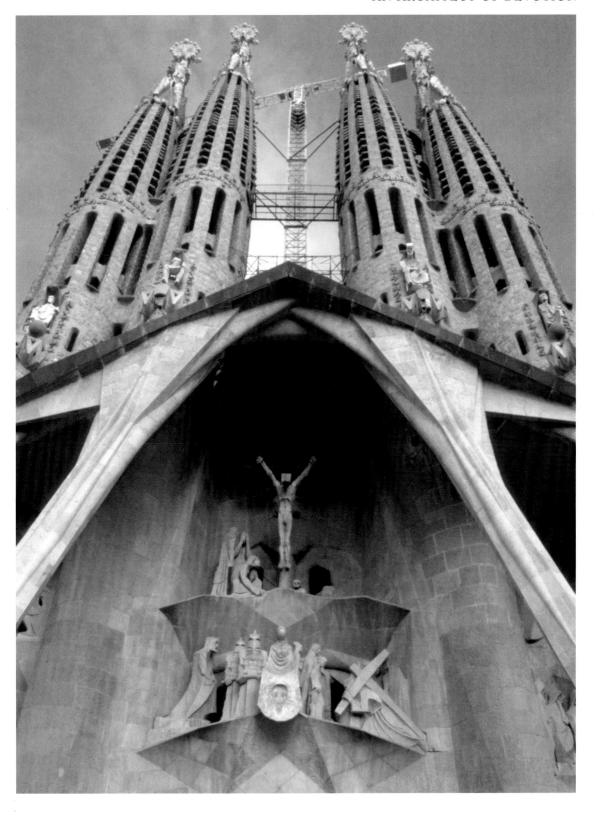

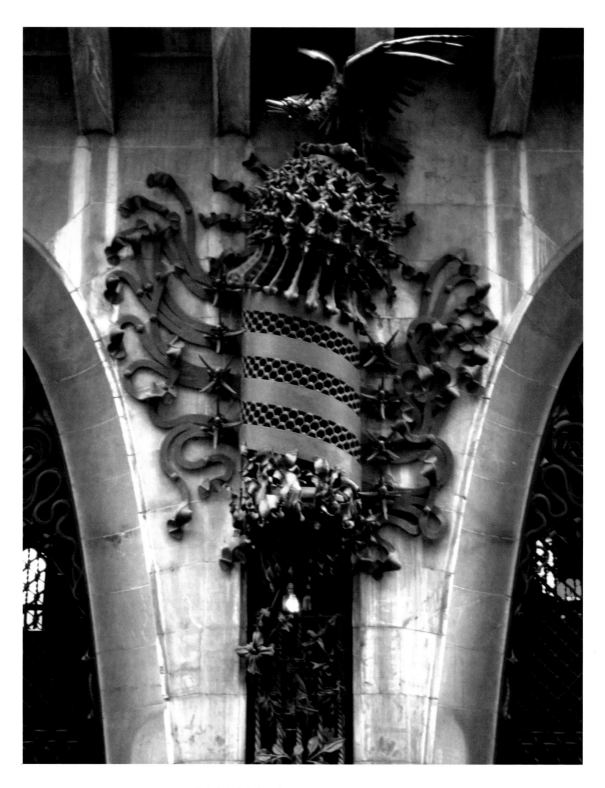

Comillas created a private estate of ostentatious mansions and monuments. He was granted the title of Marquis of Comillas in 1878 by the Spanish King, Alfonso XII, although this was probably more to do with his building of a seminary, an institution dedicated to young men preparing for the Roman Catholic priesthood, than to his industrial endeavours.

When Joan Güell died, his son Eusebi decided to appoint his own architect, and Joan Martorell's recommended candidate was Antoni Gaudí. Eusebi Güell's first commission for his new architect, in 1883, was for the design of a new hunting pavilion for a property that Güell owned in Garraf, near Sitges.

The year 1883 was undoubtedly significant in the progress of Gaudí's career for two other reasons. He both started work on the Casa Vicens, an apartment building that had been commissioned in 1878, and also at Martorell's suggestion, succeeded del Villar on the Sagrada Familia (Temple of the Holy Family) project.

This great work originally was the idea of Father Josep Manyanet, but the initial funding was raised largely by Josep Maria Bocabella i Verdaguer, who was a bookseller by profession. As early as 1866, he had founded the Josephine Associates and the journal, *El Propagador de la Devócion a San José*, through which he promoted the project to a wide and devout audience.

When Bocabella had succeeded in raising the money needed to begin the design, it was duly commissioned in 1877 from the established architect of the diocese, Francesc de Paula del Villar, who had been also one of Gaudí's professors at the school of architecture. The foundation stone of the Sagrada Familia was not laid until 1882, but during the following year del Villar had a disagreement with Joan Martorell, who was the architectural adviser to Bocabella, concerning the arrangement of the columns in the crypt. The upshot of this was that del Villar resigned.

A meeting, which was more in the form of an interview for the job, was arranged in Martorell's office between Bocabella and Gaudí. By this time the old

Left: the coat of arms of Catalonia, fashioned in wrought iron, dominates the ground floor façade of Palau Güell. It is centrally positioned between the two main entrances, which made it easier for carriages to come in and out of the vestibule which lies behind

Below left: a signed photograph of the architect, taken in 1888, the year in which he completed the Palau Güell

Below right: the architect's great patron, Eusebi Güell i Bacigalupi

bookseller was over 70 years of age, and it is not known whether or not Bocabella attached much significance to his aunt Joaquima's premonition, a little before the meeting took place, that the architect of the Sagrada Familia would have blue eyes. It was unknown to either Martorell or Gaudí beforehand, but regardless of its importance as a deciding factor, certainly the work was entrusted to Antoni Gaudí, the fair-haired architect who just happened to have blue eyes.

Eusebi Güell had recently acquired an estate on the outskirts of Barcelona between Les Corts de Sarrià and Pedralbes, and so was able to keep his architect extremely busy during the 1880s. Gaudí thus followed the Garraf pavilion with an entrance and stables for that estate (1884–87), which was followed in turn by a town palace in Barcelona, Palau Güell, 1886–89. This

is certainly an impressive building, but according to Isabel, not at all a comfortable one in which to live; upon its completion she described the new house as 'looking like a barber's shop'. Gaudí had prepared more than twenty drawings for the façade, but eventually his client settled for the balanced Venetian style.

Maybe she had a point, for the central sitting-room of what was to be the new Güell-López family home was nothing less than a representation of the cosmos, topped by an imposing central parabolic dome. Although the couple did not spend many years in the house, today it is appreciated and revered by millions as an example of individual genius and of sheer eccentricity; it was declared a National Monument in 1969, and part of the World Heritage by UNESCO in 1985. We owe a debt of eternal gratitude to Eusebi Güell, who trusted and indulged his architect's ideas without intrusion, despite his wife's apparent disdain.

Below: the house in Parc Güell in which Gaudí lived for twenty years, at first with his father and niece, and following both of their deaths, after January 1912 finally alone. The house, although it now displays some of the decoration that adorns the buildings at the entrance to Parc Güell, was not designed by Gaudí. It was renovated and converted into the Gaudí Museum in 1963

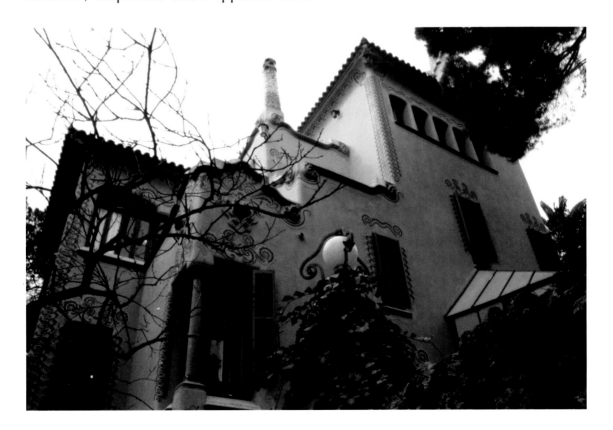

In 1904 Gaudí bought a small, unfinished, house in the grounds of Parc Güell, which is located on the slopes of the Collserola hills on the northern outskirts of Barcelona. When he moved in with his orphaned niece Rosita and his father, the latter was then 91 years old. Francesc Gaudí i Serra died on 29 October 1906, and although his death had been long anticipated, Antoni took the death of his father so badly that he even collapsed at the foot of the coffin.

After the funeral, Gaudí immersed himself in the project for a church. This was to be built in the grounds of the Güell Colony in Santa Coloma de Cerelló, and the first stone of the building was laid in 1908 although the church remains incomplete. During this time Gaudí's own health deteriorated badly, and he was forced to spend some time outside the city in order to convalesce. While he was recovering, he drew the western façade of the Sagrada Familia, which commemorates the death of Christ, and which is known as the Passion of Death.

More sadness came into his life with the death of his niece Rosa Egea i Gaudí, at the age of 36, on the 11 January 1912, and thus the architect was left alone and isolated in his house on the hill. He decided therefore to accept no further commissions, but to devote all of his energies entirely to the work of the Sagrada Familia. His losses were compounded by the further deaths, first of his associate Francesc Berenguer i Mestres in 1914, and then of his great friend and patron, Eusebi Güell i Bacigalupi, in 1918.

He walked daily from the hill of the Parc Güell to the Sagrada Familia, which would take him an hour on the downward journey, but an extra half-hour homeward bound at the end of the day. However, increasingly the aging architect preferred to spend the night on the bed that he had improvised in his cabin-like workshop, which he had erected on the side of the building works of the Sagrada Familia.

Once, when asked in the 1920s when the Sagrada Familia would be completed, Gaudí had replied that his client was not in a hurry; indeed, at the time

Right: steps of the unfinished Güell Estate Church at Santa Coloma de Cervelló, leading up over the crypt, and around an old pine tree

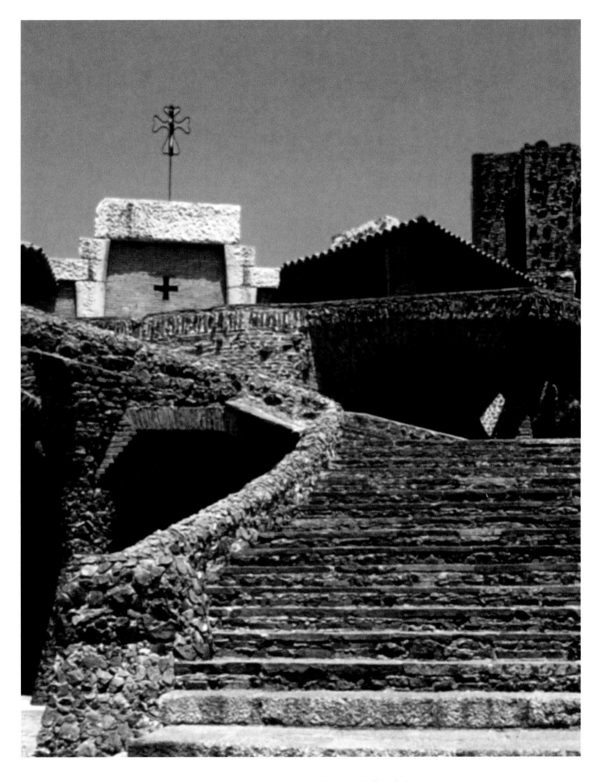

Right: the foundation
stone of the Sagrada
Familia was laid on
19 March 1882, in
accordance with the plans
of Francesc de Paula del
Villar. Gaudí replaced Villar
as the architect on
3 November 1883. The
crypt was completed by
1887 and the eastern
façade in 1900, but after
that progress was slow,
and was halted in 1914
because of a lack of funds.
Gaudí was still alive to see
the bell tower consecrated
on 30 November 1925,
sixty years before the
western façade would be
completed. It was
dedicated to St Barnabas

progress was anything but smooth. Donations for the building of the Temple had grown scarce, and there were occasions when actual building progress was paralysed. At such times the architect himself went out into the streets to solicit donations from passers-by.

During one such forced halt to the building work in 1922, a Congress of Architects of the Whole Spanish State was held in Barcelona. Teodoro de Anasagasti, a Basque architect who was one of many non-Catalans to recognise Gaudí's genius, urged the assembled delegates to save the *towering silhouette* from ruin.

Gaudí's Temple grew from his three-dimensional visions that were based on the trees that were ever-present during his life; their sturdiness, their ability to bend with the wind, their branches that stretched ever heavenwards, and their tactile leaves that playfully twisted and cavorted. He portrayed these images not only in the as yet unfinished Sagrada Familia, but also throughout his life on other buildings, in the recurring motifs of their staircases, windows, gates, balconies, roofs, and chimneys. He forsook the flat symmetry and regimentality of his masters, embarking on a sinously moving naturalism that was as alive in a sphere of its own as it was devoid of the perceived, taught and considered correctness of the time.

At about six o'clock in the afternoon of 7 June 1926, Gaudí was knocked down by a tram as he was crossing a street near Plaça Cataluna, while taking his daily walk from the Sagrada Familia to San Felipe Neri. He was taken to the Hospital of the Holy Cross where he lay gravely injured, but, because of his modest clothing and lack of any identification papers (his pockets contained no more than a few nuts and raisins and a prayer book), no one recognised him until two days later, shortly before his death. He never regained consciousness. His beloved Sagrada Familia, a legacy to us all which is both an emotional interpretation of living with the environment and a Christian poem carved in stone, may even yet be the reason for the raising to sainthood of Antoni Gaudí i Cornet.

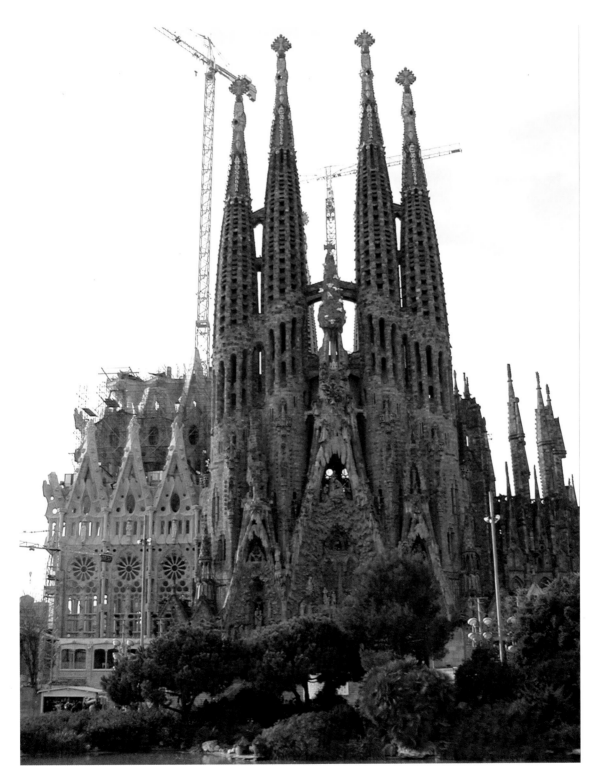

The Gaudí Museum

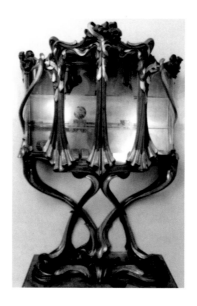

*The Museum grounds contain items, both originals and copies, from some of Gaudí's many buildings, including **right**, a Sagrada Familia cosmos, 1900. Items of furniture inside include a sofa, **below**, and a cabinet, **left**, which he designed with Aleix Clapés for the Ibarz-Marco house, 1898–1904*

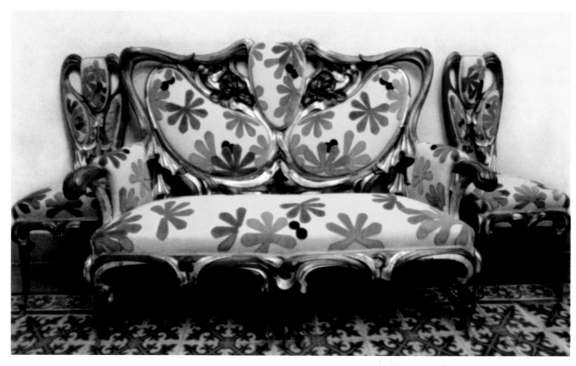

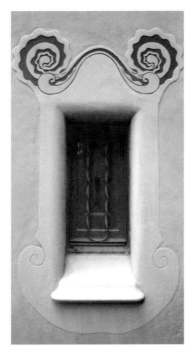

The house also incorporates many Gaudí artifacts, having typical Gaudí ironwork gates, **below**, and window decoration, **left**.

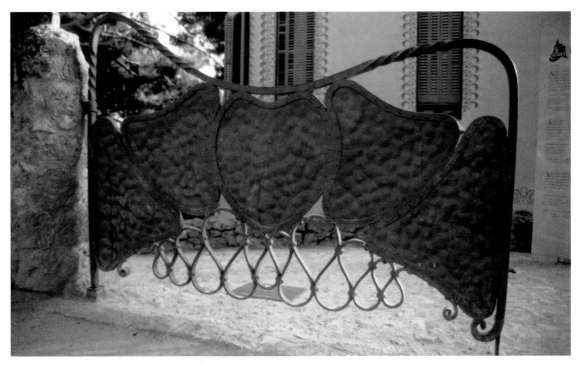

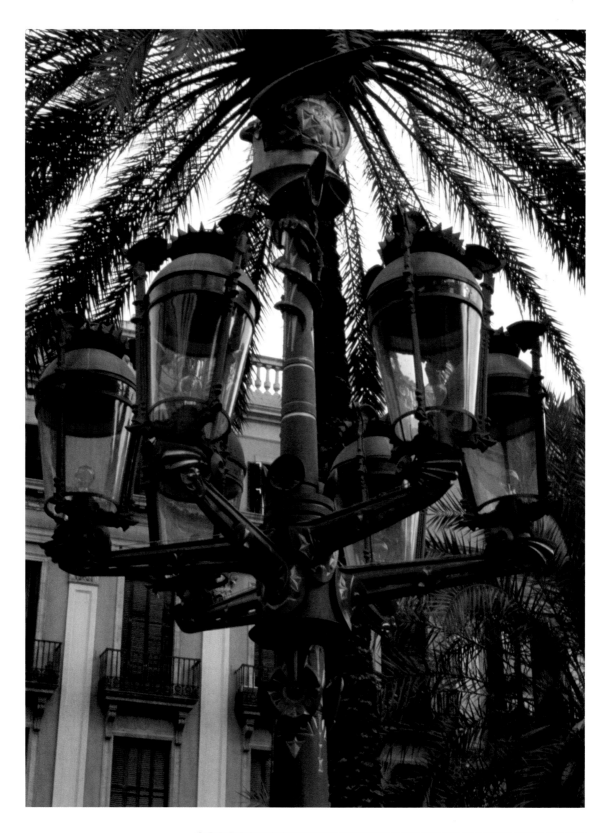

EARLY BUILDINGS

1878–1882

G AUDÍ OBTAINED HIS DIPLOMA IN ARCHITECTURE from the Escola Provincial d'Architectura de Barcelona on 15 March 1878, from when he was destined to become the most outstanding and widely-recognised figure in twentieth-century Catalan architecture.

Prior to his graduation he is believed to have collaborated on the building of the Montserrat monastery with the architects, Joan Martorell and Francesc de Paula del Villar, and with the master builder, Josep Fontseré, on works for the Parc de la Ciutadella, Barcelona, although there is considerable uncertainty as to the extent of his collaboration.

The first works he undertook in his own right once qualified included the lamp posts in Plaça Reial, Barcelona, 1878; the lighting (which was never built) for the Passeig de Muralla del Mar, Barcelona, 1881; the design of windows for Esteve Comella, a glove merchant, and the design of the social housing scheme for the Cooperativa Obrera Mataronense, Mataró, begun in 1878.

In his early work it is already possible to see the beginnings of his use of conic sections. These are

Left: a six-light streetlight in Plaça Reial, Barcelona, 1878. This was the first of Gaudí's works to use bright and colourful elements, and was said by many to demonstrate the architect's search for an expressive form. This search was something that was to become evident in his first completed works; although Casa Vicens, the Güell stables and the El Capricho villa in Comillas, Santander, were not the forerunners of modernism, they were an affirmation of a new tendency in taste

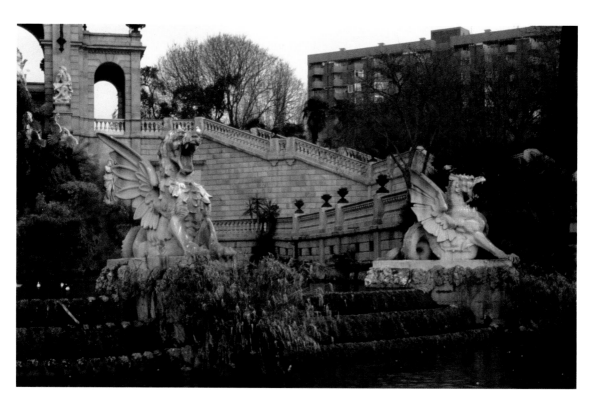

Above: *the fountain in the Parc de la Ciutadella, 1873–77, was built by Josep Fontseré, with the assistance of Gaudí*

Left: *a detail from the rear side of the fountain*

Right: *wooden arches in the factory of the Cooperativa Obrera Mataronense*

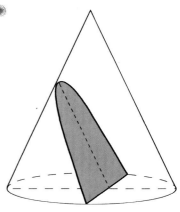

formed in two ways. In the first, a plane at the same angle as the curved plane of a cone, intersects that curved plane from inside the cone. This produces a parabolic arch, *illustration page 86*. The second form is produced in the same way, except that the intersecting plane forms a right angle at its base with the base of the cone. This produces a hyperbolic arch. Gaudí took this as a linear element and developed it into a three-dimensional dynamic and spatial form, the hyperboloid.

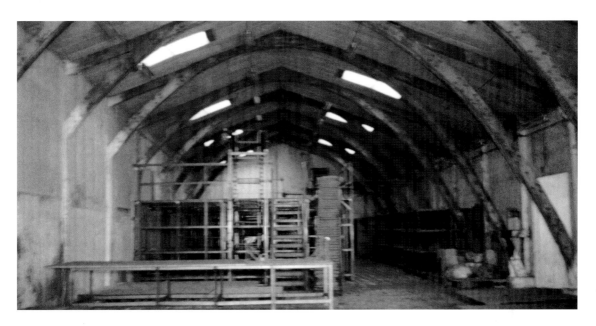

The main part of the fountain structure at the Parc de la Ciutadella in Barcelona contains a parabolic arch ceiling, as does the pavilion roof for the Cooperativa Obrera Mataronense. Gaudí continued its development, expanding, modifying and perfecting it throughout the course of his life. The form can be seen in the windows in the façade of the Güell estate, and the Palau Güell entrances. The arch has been evolved into a subtle element of spatial partition at the Colegio de las Teresianas, reaching its zenith in the towers of the Sagrada Familia, and in the disposition and reciprocal links which are first evident in the project for a Franciscan Mission residence in Tangiers, 1892–99.

Top: parabolic, and, ***below,*** hyperbolic arches

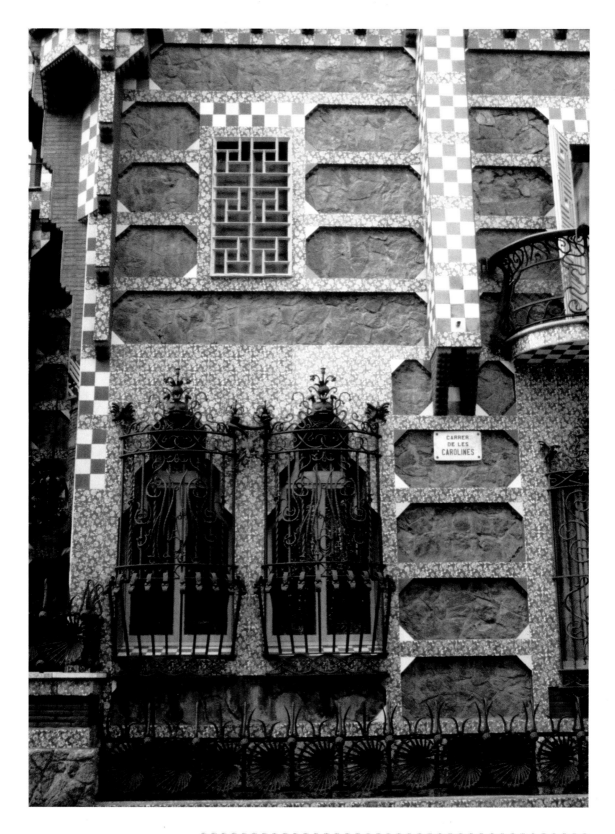

CASA VICENS

1883–1888

MANUEL VICENS I MONTANER, a ceramic tile manufacturer, approached Gaudí in 1883 to design an apartment building that was to be a summer residence, and was also the architect's first private dwelling commission. The two-storey building, which is on a more-or-less square plot at 24 Calle les Carolines, when viewed from a distance is reminiscent of Arabic structures with its geometric ornaments, and is even surmounted by small Moorish-style towers.

The façade is adorned with many protruding gables and with extensive extravagant green and white ceramic tile decoration. Many of these tiles are painted with luminescent orange *tagetes* (marigolds), that Gaudí had discovered growing in the garden when he first visited the site and had then copied. Other building materials evidently came from Montaner's own factory, and so appear to be a catalogue of its production.

Although the outstanding elements are oriental in styling, the cast-iron garden gates that are designed with the fingered palm leaf motif give more of an *art nouveau* impression, and the small cherubs that sit on the edge of the balcony refer back to the baroque.

Left: the lower façade of Casa Vicens, at 24 Calle les Carolines, Barcelona. Gaudí built it for a brick and tile manufacturer, who almost went bankrupt because of the cost of its construction. Manuel Vicens i Montaner recovered from his near-bankrupcy to enjoy the profits made from the ceramic tiles that he manufactured for floor decoration, a fashion that Casa Vicens had initiated

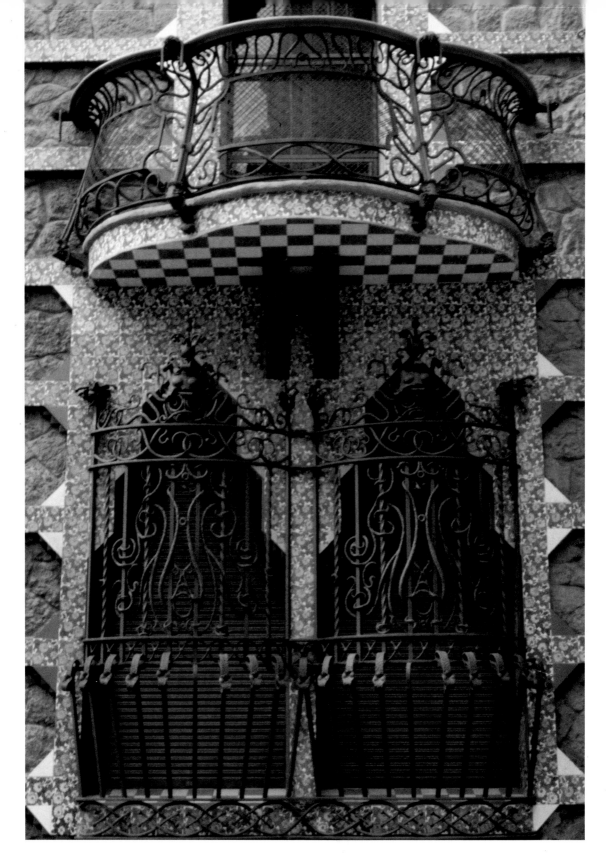

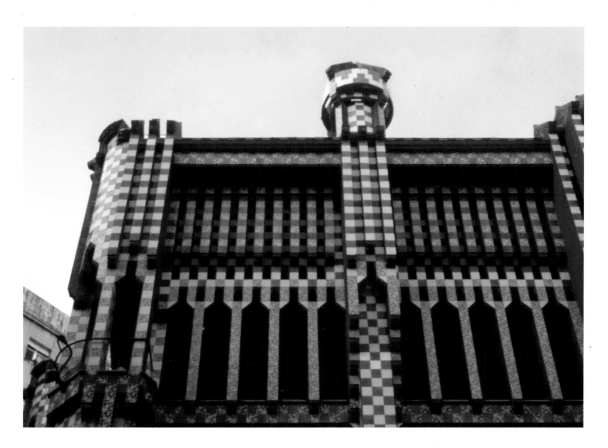

In the garden Gaudí created a beautiful monumental fountain with a parabolic arch and a brick-built waterfall, but this is no longer there, having been destroyed soon after the house was completed.

The extensive use of tile ornamentation is continued inside the house, with the dining room being the most lavishly decorated. It is also the room that is most in keeping with the *art nouveau* style, with a cherry branch patterning on the stucco between the heavy wooden ceiling beams; walls decorated with ivy vines; and the door surrounds painted with bird motifs.

Casa Vicens was extended and modified in 1925, although not by Gaudí, who was unable to accept the commission. With his consent, instead the work was undertaken by J B Serra Martínez who respected Gaudí's style, but this has left the exact configuration of the original building somewhat unclear today.

Left: detail of a window, with ironwork balcony railings and a tiled surround

Above: the façade of the upper storey on the street side

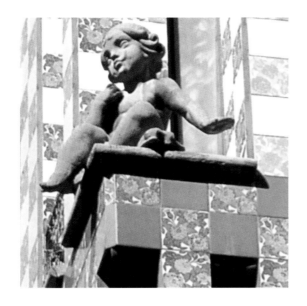

Left: *one of the small figures, that sit like cherubs on the edge of a smaller balcony and help to give this quite small house the appearance of a fairytale castle, in its combination of originality and imagination, its mixture of styles and use of ceramic tiling. Casa Vicens is a building that begins at ground level in a decidedly Spanish vein, becoming increasingly more Arabic the higher up it rises*

Above: *the yellow flowers that decorate these tiles are said to have been inspired by a tree that was covered in tiny yellow flowers, that was growing in the grounds*

The leaves depicted in the wrought iron railings, **far left below***, and in the main door of the house,* **left***, are inspired by a luxuriant palmetto tree. This same motif was also used by Gaudí in the iron gateways and end areas of the Casa El Capricho at Comillas*

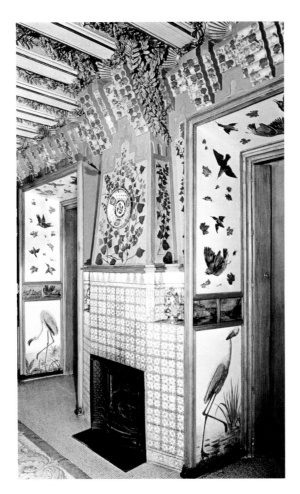

Right: *this ceiling belongs to a small room on the first floor of Casa Vicens, and is so designed as to create the illusion of an open dome through which the sky may be observed*

Below: *the impressive, though small, smoking lounge is designed with ceramic tiles at the foot of the walls. Above these is a coloured relief, made from pressed board, with stalactite-like formations hanging from the ceiling*

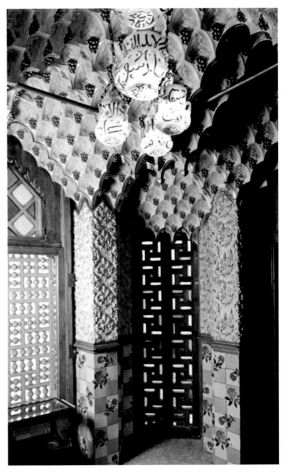

Above: *the doorway surrounds on each side of the fireplace in the dining room are decorated with bird motifs, and the ceiling stucco decorations between the huge beams are designed to represent cherry branches*

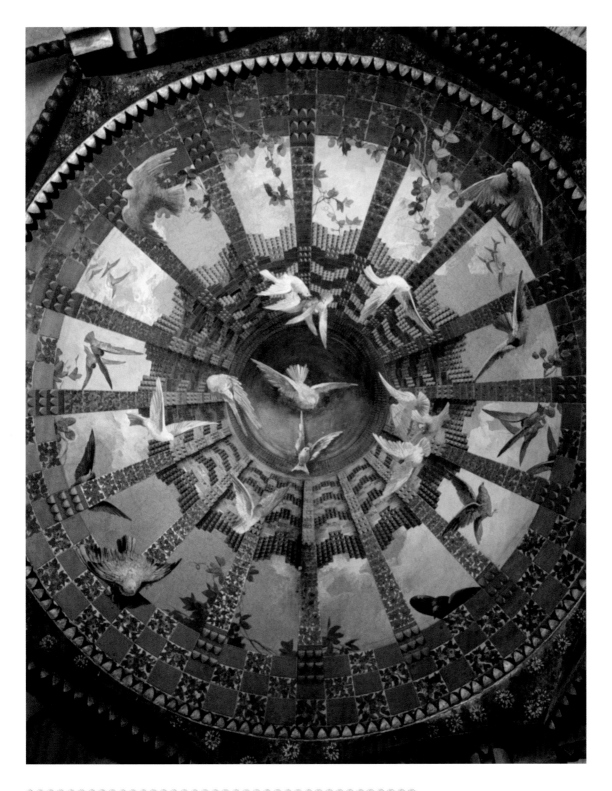

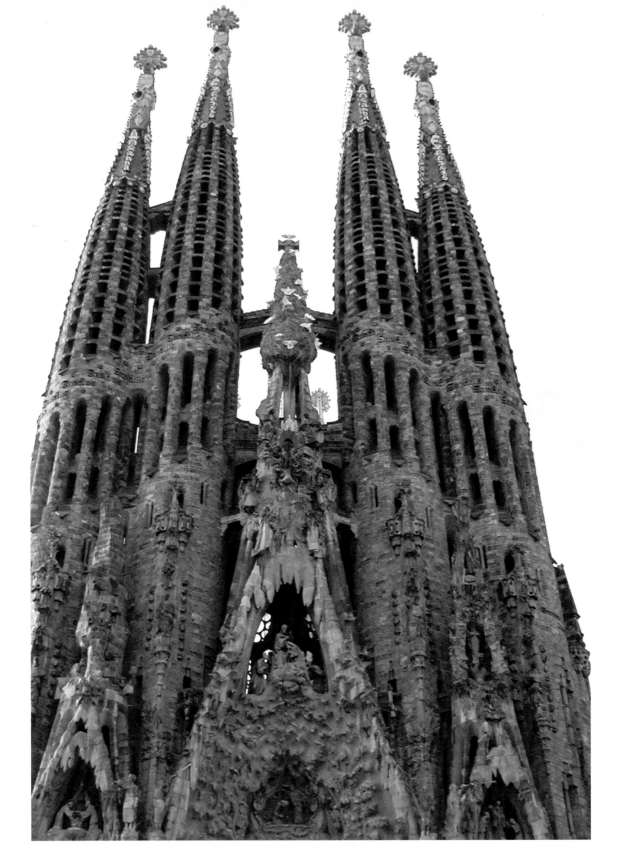

THE SAGRADA FAMILIA

1883–1926, and after

THE ARCHITECT FRANCESC DE PAULA DEL VILLAR had started the crypt of the Sagrada Familia in 1882, having been contracted by Josep Maria Bocabella i Verdaguer, a bookseller from Barcelona. The latter had bought the land and sponsored the construction of a church to be dedicated to San José, his patron saint, and to the Sagrada Familia (Holy Family), with the intention that it would be the region's emblem, signifying the growth that the city had enjoyed.

However, shortly after del Villar had built the crypt in a neogothic style, he had an argument with Bocabella's consultant architect Joan Martorell, the result of which was that del Villar resigned from the project. Martorell was reluctant to assume responsibility for the work himself, and suggested instead the services of the young Antoni Gaudí, who took on the lifelong task of continuing with the architectural responsibilities of the church building works, on 3 November 1883.

His first task was to correct the unsuitability of

Left: progress has been slow, even by cathedral standards, so that behind the Nativity façade his marvellous Temple is still a building site, 75 years after the death of Antoni Gaudí

Overleaf: the Crowning of the Virgin Mary in the central Portal of Love, on the eastern façade

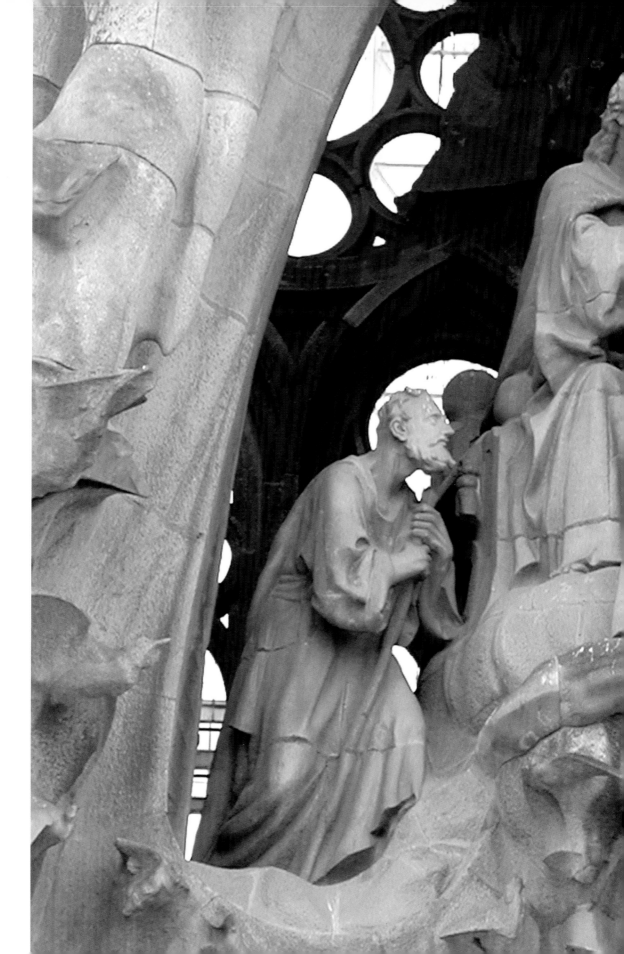

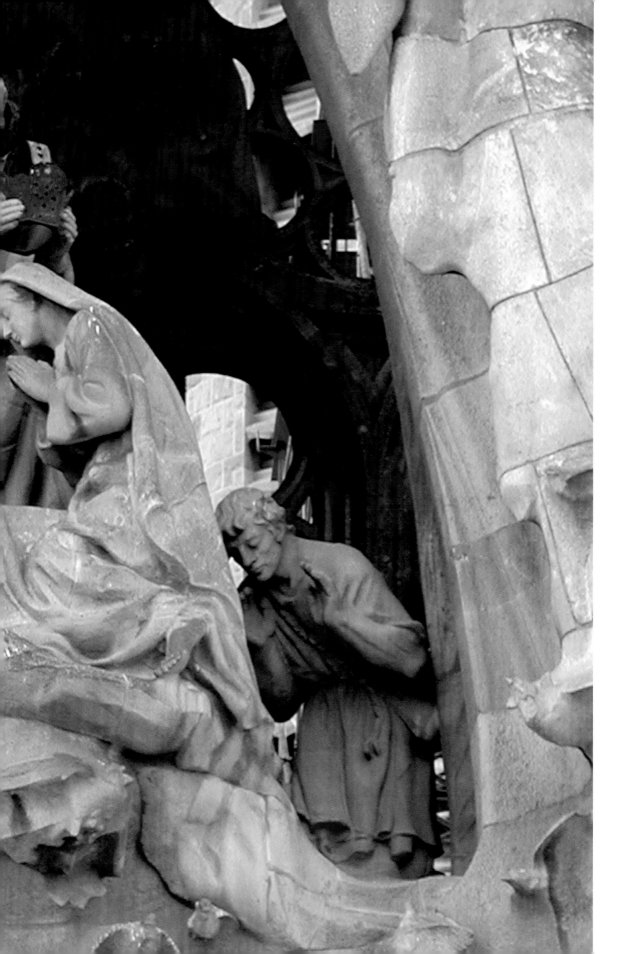

Below: looking up into the unfinished south crossing, where Gaudí's internal trees are clearly visible, their branches reaching up and out to support the structure of the Temple. Using eucalyptus trees as his model for the load-bearing capacity, he

the gothic style employed in del Villar's crypt by applying the structural solutions he had studied and with which he had experimented. He carried out tests in function which resulted in the now famous internal rampart arches, the crosses, or crutches as he called them, which he used to transfer the balancing forces of the construction to the inside of the church. Thus we see the appearance of the columns, the trees like an airy forest in the interior of the church, which follow the inclination of the resultant dynamic forces.

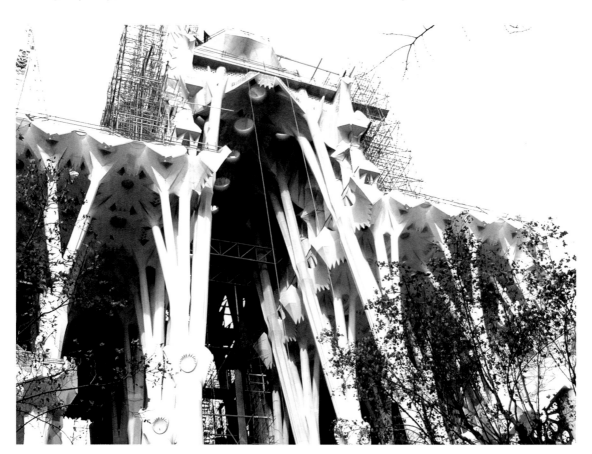

developed this forest of stone, a form not dissimilar to that later used by Sir Norman Foster for his Stansted Airport building,

The crypt bears Gaudí's trademarks only to a limited extent; nevertheless he expanded del Villar's porthole-like windows, and moved the arches higher so that the space received much more light and so was less oppressive than it would have been originally.

The Temple of the Sagrada Familia was conceived by Gaudí as a basilica with five naves; its ground plan is shaped as a cross, a transept with three aisles, the entrances to which are via the three portals in the eastern and western façades. The main nave, inclusive of the apse, was planned to be 95m (311ft) long, and the transept to be 60m (196ft) long.

The towers that would frame the respective portals adorning each façade were originally intended to be rectangular in plan, but Gaudí later decided to

England, 1981–85. The great benefit of this construction system is that the columns appear to bear no weight at all

Below: *the sun sets behind the spires on the western façade of the unfinished Sagrada Familia*

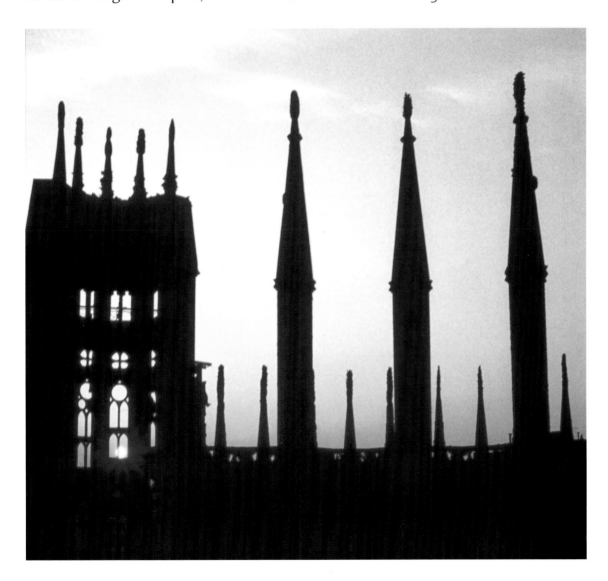

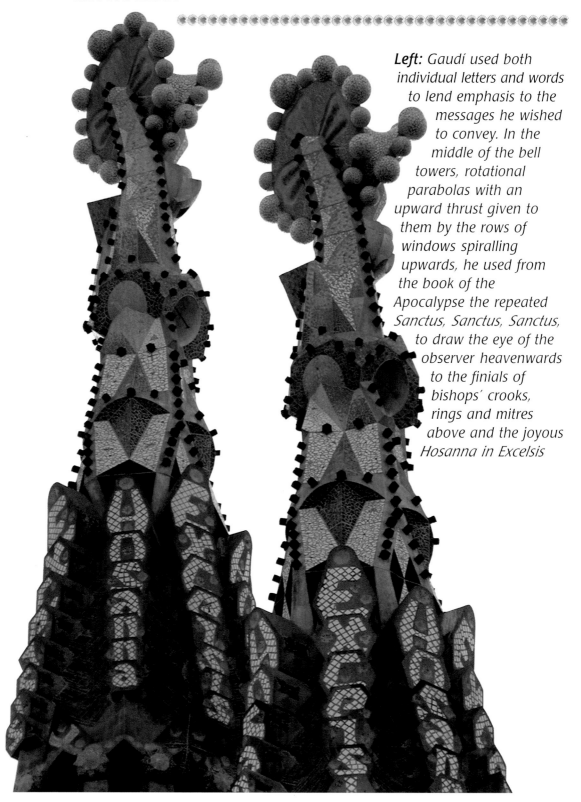

Left: *Gaudí used both individual letters and words to lend emphasis to the messages he wished to convey. In the middle of the bell towers, rotational parabolas with an upward thrust given to them by the rows of windows spiralling upwards, he used from the book of the Apocalypse the repeated Sanctus, Sanctus, Sanctus, to draw the eye of the observer heavenwards to the finials of bishops' crooks, rings and mitres above and the joyous Hosanna in Excelsis*

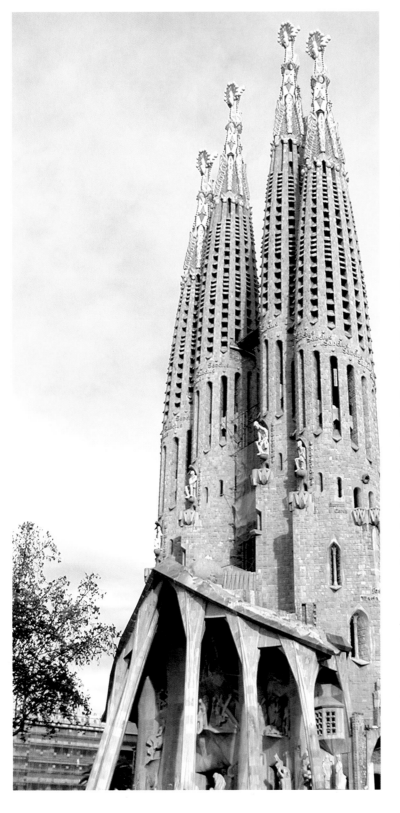

Left: *Gaudí preferred, rather than to follow a pre-determined plan, instead to evolve the project as the construction work progressed. However, the overall model did envisage twelve bell towers, four for each of the three main façades, with each tower being dedicated to one of the Apostles. Just as the Apostles were symbolised as bishops in the heirarchy of the church, the towers take on an analogous episcopal aspect. Each ends in a sort of bishop's mitre, especially obvious when viewed from afar, and the entire tower takes on the form of an episcopal shepherd's crook.*

It was only in his mind that Gaudí visualised the spires, and their impact upon the skyline of the city of Barcelona where now they dominate, the cathedral calling to its worshippers like a beacon

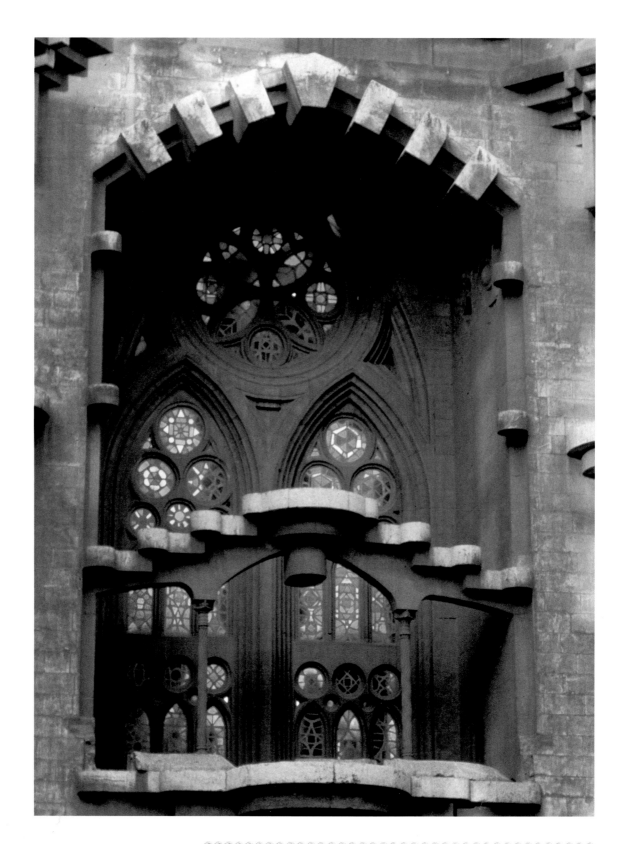

make them round in order to avoid having them protrude sharply above the portals. These towers, with which everyone is now so familiar, also taper towards the top; designed as rotational parabolas, they have an upward thrust granted to them by the rows of windows that spiral up the towers, lifting the eye with them, ever upward to the colourful rounded pinnacles.

His real achievement, though, starts with the apse over the crypt. Here Gaudí has retained the gothic window but made it less formal by counterbalancing against it different circular elements, including the seven chapels that fan out from the altar, which is located in the visual and symbolic centre of the building.

'My best friends are dead; I have no family, no clients, no fortune, nothing. Now I can devote myself entirely to the Temple', wryly mused Gaudí in 1918, after the death of his one true friend, his patron Eusebi Güell. Although Gaudí's involvement with the Sagrada Familia

Left: the gothic window, showing its stone tracery and stained glass, from the interior of the central (Nativity) part of the eastern façade at the end of the transept

Below: the Three Wise Men, offering gold, frankincense and myrrh, flank the left-hand side of the central portal of the eastern façade

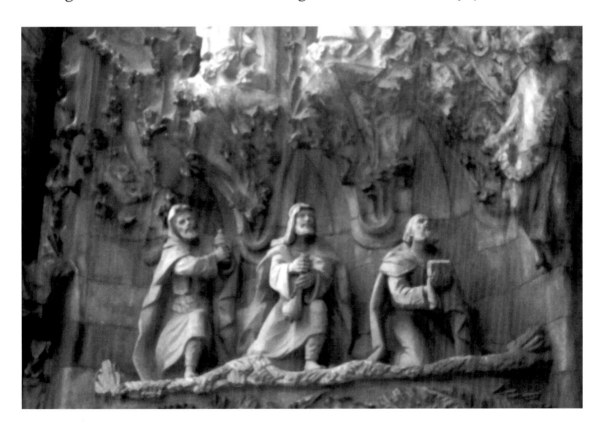

dates from 1883, it was not until about 1914 that his concern for its construction excluded all else, and this focus continued until the very end of his life. Such was his absorption in the project during the construction, that at one point he even lived inside the works site.

Gaudí famously is supposed to have conjectured that 'my client is in no hurry', but although the great architect lived to a great age, by the time of his death he had seen only his crypt and the outline of the portals on the eastern façade completed, although work on the four bell towers, also on the eastern façade, had reached heights in excess of 30.5m (100ft), and the tower dedicated to St Barnabas was consecrated in 1925.

Traditionally it has been one of the purposes of the Church to impart the word of God to worshippers. When the vast majority of these were both poor and uneducated, this was achieved by visual means within the buildings themselves, in the murals of biblical scenes that adorned the walls and later the images portrayed in stained-glass windows. The form of the Sagrada Familia follows this symbolising function; Gaudí's building is thus not just a place of worship, but an open book from which all are invited to read.

The twelve towers representing the Apostles

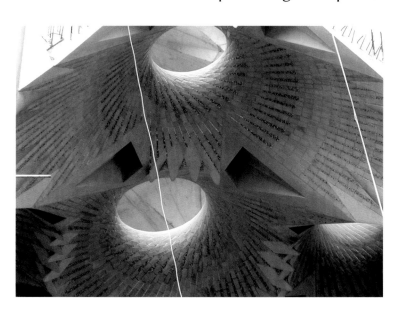

Right: the sunbursts that adorn the vaulting of the southern side of the cathedral allowed Gaudí to introduce the colours of nature to his creation

surround the centre, or body of Christ, at the heart of which is the altar. The cathedral's main spire, which was planned to reach a height of 170m (557ft), is crowned by a cross; symbolic of Christ, it shows the saviour of mankind rising above all else.

Gaudí planned the three façades to replicate three phases of Christ's ministry, but only lived long enough to see work on the eastern 'Christmas' façade. He began this first, as at the time he considered it to be more socially acceptable for the first façade than either that of the Saviour of Mankind or that of the Day of Judgment. After all, the first light also comes from the east, and with it salvation, while the sun sets to the west when the day is over and where the façade of the Passion depicts the suffering of Christ.

The eastern façade shows scenes from the life of Christ on Earth. In its central and largest portal, the Portal of Love, we see the Birth of Christ; in the portal to the left, the Portal of Hope, is a scene depicting the Flight from Egypt and the Massacre of the Innocents (Herod's murder of the children); while on the right is the Portal of Faith, which illustrates more biblical scenes, including the Revelation of Saint John the Divine.

The third façade, that on the southern side, was to be approached by a wide staircase leading up to the Glory of God. The portals were to depict the Creed – a statement of faith and a step towards salvation, shown by glowing letters that were to flare up between the bell towers; the Portal of Death and Hell; and a third portal depicting the Fall from Grace. Yet more symbolism can be found in the repeated portrayals of carpenter's tools, including one of Jesus using a mallet and chisel. These tools are those of Joseph, to whom the main chapel in the crypt is dedicated, and who is depicted throughout the Temple as the guardian of the church.

With its five naves and an impenetrable forest of columns, the Expiatory Temple of the Sagrada Familia is unquestionably Gaudí's most complex work. It encompasses both his structural experiments and his fruitful imagination that conspired to create audacious

Above: *a pillar next to the Portal of Love springs from the shell of an unconcerned tortoise, suggesting an impression of lightness*

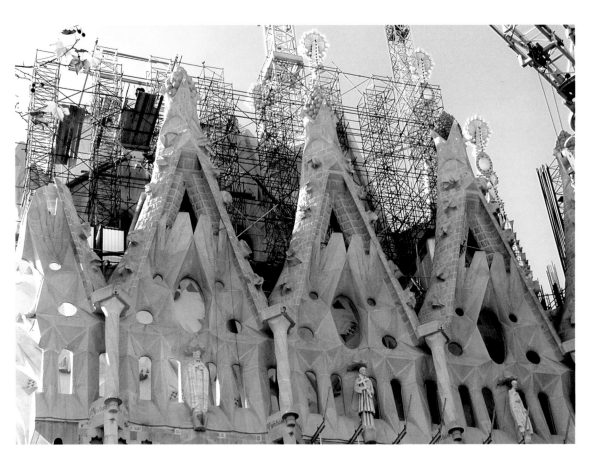

Above: *more recent work on the Temple has seen the southern transept taking shape. Its lightness and structure as well as its decoration are decidedly in character with the architect's dreams of many years earlier*

organic forms and the rationalist inner structures that were needed to sustain them. The great Temple is also the ultimate example of Gaudi's development of the parabolic arch, which he interlinked with slanting columns to bear the immense weight of the vaults. This was a technique he used successfully, albeit on a smaller scale, at the Colegio de las Teresianas.

Gaudí's devotion to the Temple spanned forty years. After his death, the work was continued by his collaborator, Domènech Sugrañes. He completed first the four towers of the eastern façade and, by 1933, that entire Nativity façade. Although Gaudí frequently altered and adjusted his ideas for the Temple, and at the time of his death was a long way from finalising this massive undertaking, he did leave both plans and a plaster model of what were, at the time, his intentions

− the plaster model was deliberately destroyed during the Spanish Civil War, but was later reconstructed. Work since then on the Sagrada Familia has been painfully slow. Although the intention was to follow Gaudí's model and plans as closely as possible, responsibility for the design work on the portals of the western façade, which began in 1956, was handed over to the Barcelona sculptor Josep Maria Subirachs in 1986, who has re-interpreted the Gaudí design and produced a vision quite different to anything that Gaudí would have conceived, although he has introduced a number of sculptural references to Gaudí's darker, more sinister aspect.

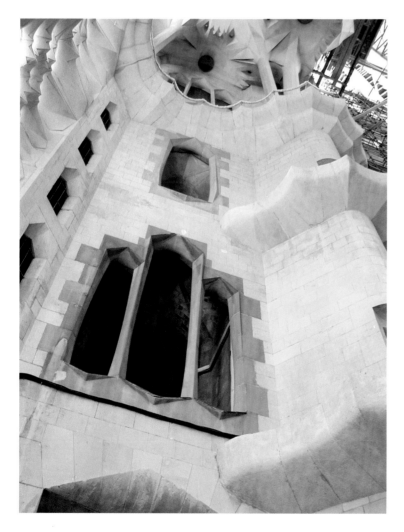

Left: *inside the church at a point south of the western front, the use of natural forms is combined with a practical functionality; these internal windows provide light to the clerestory*

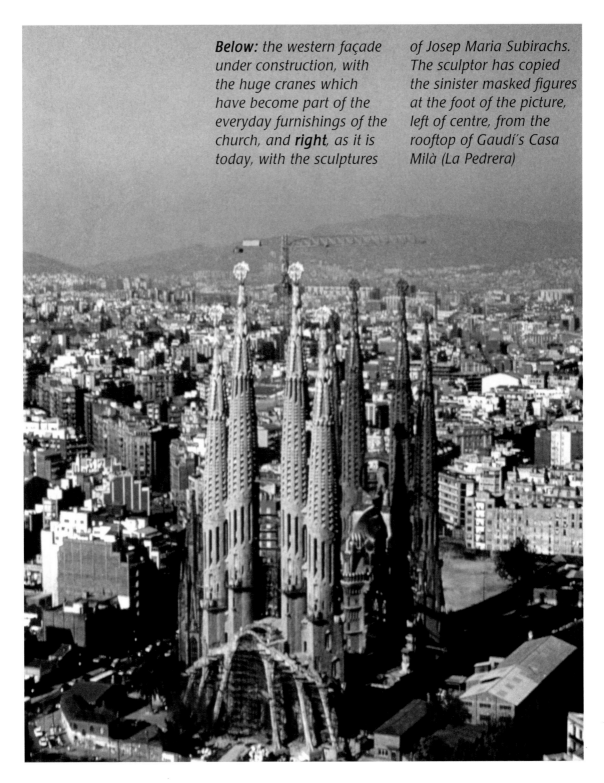

Below: the western façade under construction, with the huge cranes which have become part of the everyday furnishings of the church, and **right**, as it is today, with the sculptures of Josep Maria Subirachs. The sculptor has copied the sinister masked figures at the foot of the picture, left of centre, from the rooftop of Gaudí's Casa Milà (La Pedrera)

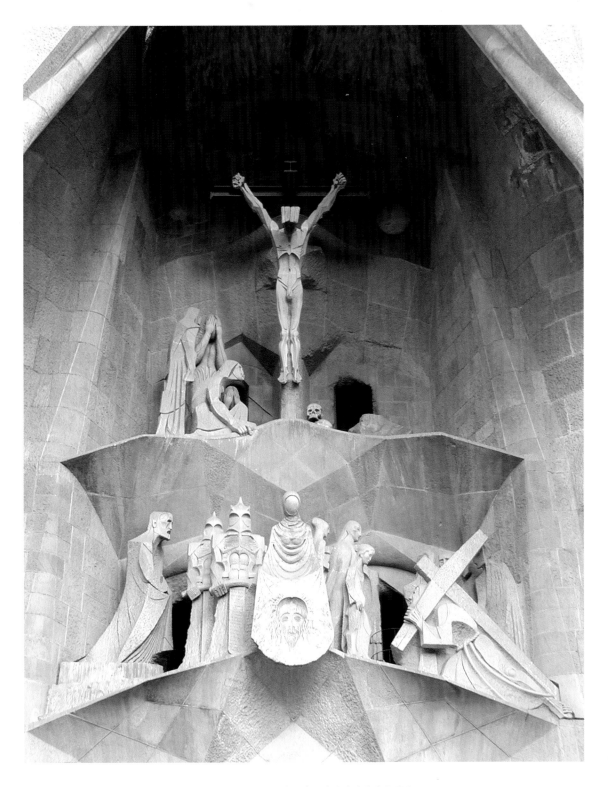

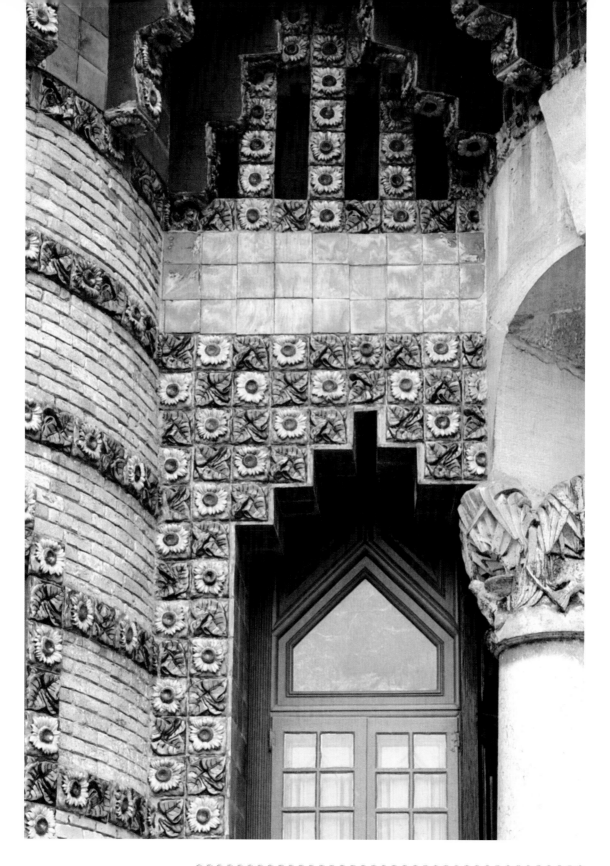

CASA
EL CAPRICHO

1883–1885

SUNFLOWER MOTIFS ON COLOURED TILES adorn the external walls of the house in Comillas, near Santander in northern Spain, that Gaudí designed for the wealthy bachelor Don Máximo Díaz de Quijano.

This was one of four projects that Gaudí undertook in 1883, for in addition to succeeding del Villar on the Sagrada Familia and working on Casa Vicens, he agreed also to design the El Capricho country house, and to design for Eusebi Güell the hunting pavilion at Garraf, near Sitges. Although the latter was never built, its design did have some similarities with that of El Capricho: for instance, the entrance portico, minaret and the overall Moorishness of the two buildings. As a result of these various commitments Gaudí spent most of his time in Barcelona, and so had to delegate the supervision of the building work at Comillas to the architect Cristófol Cascante i Colom; in

Left: golden sunflowers and green foliage tiles abound around the entire façades of El Capricho. The entrance to the house is to the right of the picture and is approached via stone steps, through large stone arches which are supported on bulky columns but which have delicately carved capitals. The whole portico conveys the impression of being on legs, above which rises the body of the whimsical and functionless minaret

fact, Gaudí never was able to spare sufficient time in which to make even a single visit to the site.

The house is set in the middle of a lush green plot, and although it is often referred to as being small, the ground floor plan measures some 35.5 x 15.4 metres (117 x 50 feet). Perhaps it is the exuberant detailing and ornamentation that takes the observer's eye and detracts from the overall bulk and solidity, the massive presence, of the building. Here Gaudí has achieved a colourful impression on a Moorish-Oriental theme through his use of the sunflower tiles, though they are less colourful than the *tagetes* used on the tile decoration of Casa Vicens, and their formal disposition produces in the building a more solid, if not cumbersome, aspect.

Between the bands of tiles on the façades are nine rows of bricks of varying colours. These lines, especially along the northern façade, are broken by a number of large windows; the largest of these is a main source of light for the capacious salon. This room is the focal point of the inside of the house, reaching from below ground-floor level up into the attic of the house. It forms a core, from which the other rooms that are grouped around it lead off. After all, the house was designed to suit the requirements of a single gentleman whose lifestyle included much entertaining and socialising, and it is thus quite unlike the cosy family home that Gaudí created in Casa Vicens.

Although it can be said that El Capricho does not display any of Gaudí's technical innovations, like Casa Vicens it echoes the architect's interest in the architecture of primarily Arabic descent, while displaying the ability to blend it with his own Catalan heritage.

These two buildings, together with the unbuilt pavilion at Garraf and his next building, that of the Güell Estate, are littered with Moorish and the derived *mudéjar* references, and although he used a more varied mix of tiles on the Estate, he still managed to introduce an aura of austerity, so that these buildings when taken together represent a definite evolution in the unique emerging style that was being forged by a great man.

Right: balconies with their built-in seats on the northern façade of the house are covered with heavy wrought-iron arbours. The one in the foreground of the picture is on the north-western corner of the salon, of which the main window, with its heavy wooden frame, can be seen to the left of the balcony

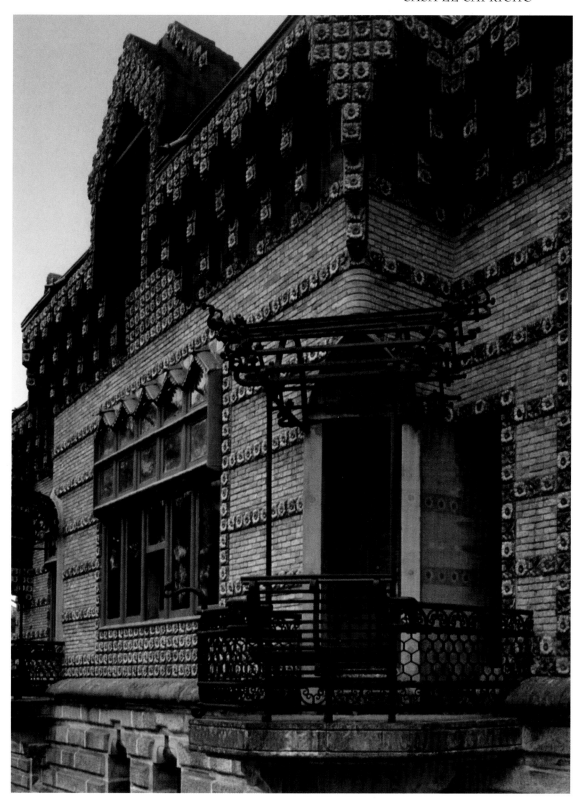

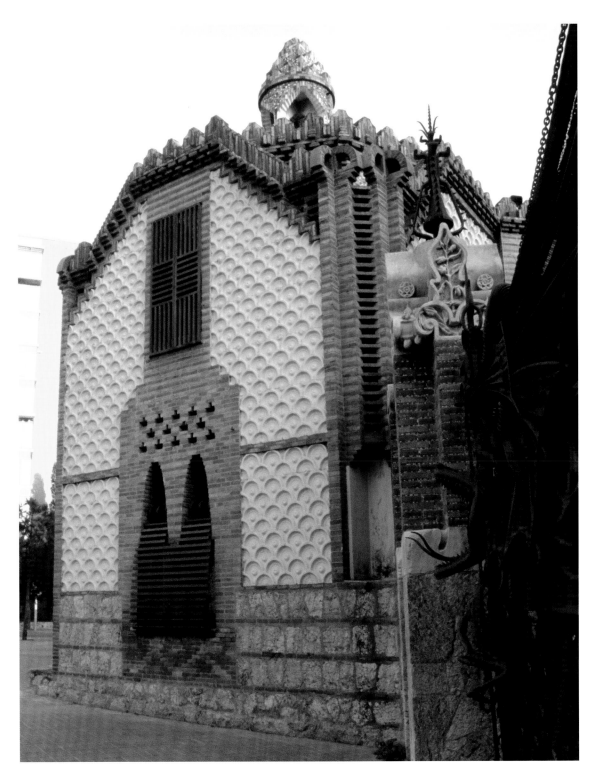

GÜELL ESTATE

1884–1887

EUSEBI GÜELL ACQUIRED AN ESTATE on the outskirts of Barcelona at Les Corts de Sarrià in 1883. There he planned to stable the horses which were then necessary to convey him and his family around the city. He immediately commissioned his architect, Antoni Gaudí, both to carry out some restoration on the existing estate, and to construct some extra buildings so that the estate should function properly as a stable complex.

Gaudí chose to continue for the new buildings with the *mudéjar* style of Casa Vicens and El Capricho, but by this time he had sufficient experience of the effects that he was creating to be able to refine his ideas. In what was to be his last building with these overtly Moorish overtones, his exploitation, implementation and achievement of the style is magnificent.

The refinements that he perfected can be seen both in the creation of the turrets at the Güell estate, which are less fanciful than that at El Capricho, and in his use of an abstract motif for the tiling, in place of the *tagetes* at Casa Vicens and the sunflowers at El Capricho. In addition, whereas the two previous buildings had

Left: the porter's lodge with its tile-decorated ventilators, and walls of stone, brick and stucco. To the right of the picture is the wrought-iron dragon gate, and between it and the lodge the pedestrian entrance

been individual detached houses, the Güell estate introduced a different problem. Here there were three main distinct buildings: a porter's lodge, the stables, and a riding school. All had to be united as one cohesive whole, for Güell had instructed Gaudí to create not just a functioning estate, but one which reflected this very wealthy man's standing in the community. Gaudí used stucco on the estate's walls to give a uniform honey-coloured surface as the medium for a formal semi-circular decoration, magnificently achieving the first objective.

For the 4.57m (15ft) wide entrance gate, the architect has drawn on ancient myth, combining it with his consummate ability to fashion wrought iron to create the hugely impressive dragon gate. The post to the left of the gate is topped by a bell. That on the right, from which the gate is hung, rises to more than 9m (29.5ft) and is surmounted by a golden apple tree; half-way up

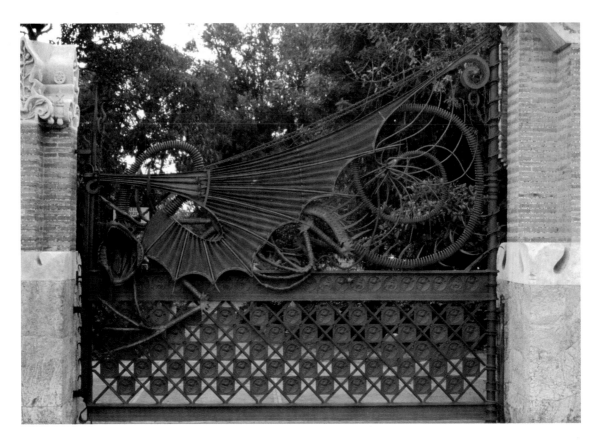

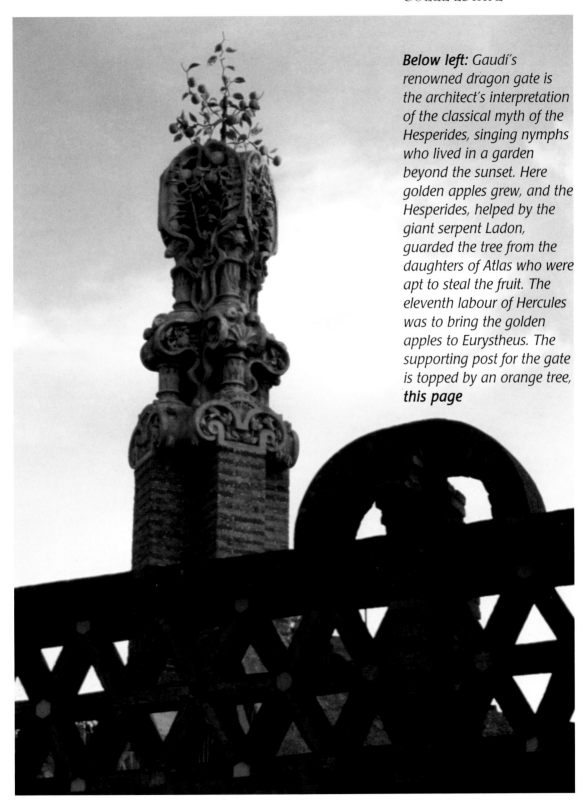

Below left: *Gaudí's renowned dragon gate is the architect's interpretation of the classical myth of the Hesperides, singing nymphs who lived in a garden beyond the sunset. Here golden apples grew, and the Hesperides, helped by the giant serpent Ladon, guarded the tree from the daughters of Atlas who were apt to steal the fruit. The eleventh labour of Hercules was to bring the golden apples to Eurystheus. The supporting post for the gate is topped by an orange tree,* **this page**

Right: to the right of the entrance gate is the riding school; its domed roof is crowned by a little tower of clearly Moorish influence

Below: one of the tiled ventilators on top of the roof of the porter's lodge

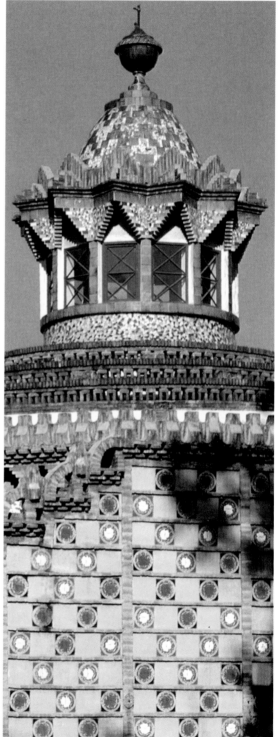

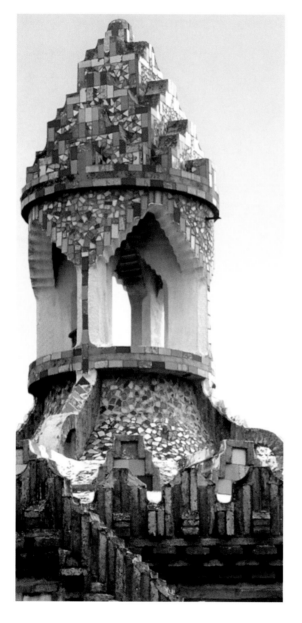

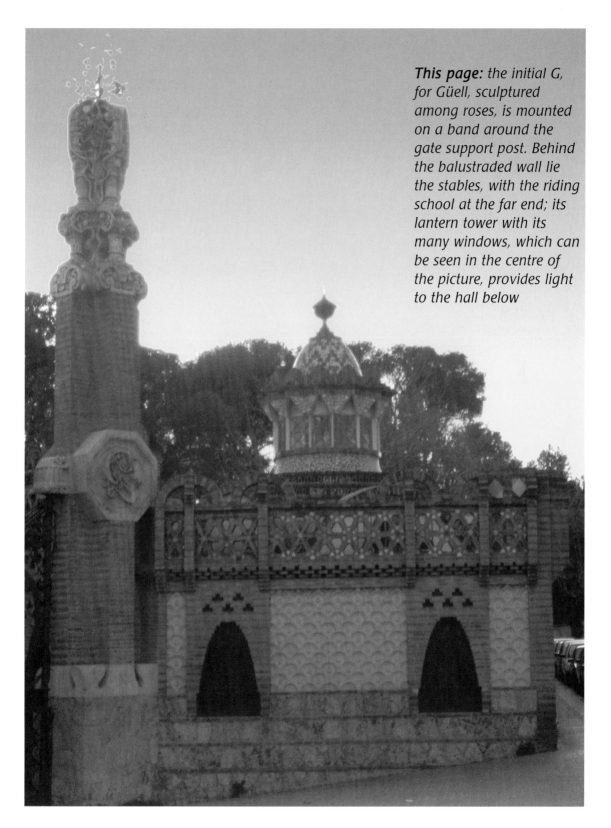

This page: the initial G, for Güell, sculptured among roses, is mounted on a band around the gate support post. Behind the balustraded wall lie the stables, with the riding school at the far end; its lantern tower with its many windows, which can be seen in the centre of the picture, provides light to the hall below

63

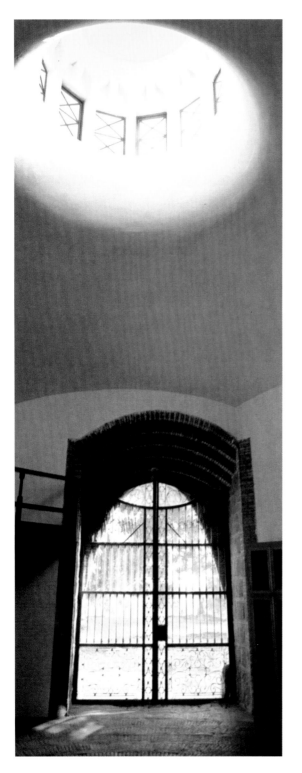

Left: light from the windowed lantern in the cupola is reflected off the walls to illuminate the riding school, which is entered through a doorway formed by a parabolic arch

Right: the stables, which are attached to the riding school, have a roof covered externally in white pipes, giving no indication of the elegant catenary arches and brick vaults below them

Far right: the stone, brick and ceramic stairway, as it was in 1893 when it formed the part of the estate created by Gaudí. The staircase, which was formed over a parabolic arch, was demolished in 1919

the gatepost is a large sculpted letter 'G' set among roses, echoed in motifs in the ironwork of the lower half of the gate. Both posts are filled between the bricks with tiny fragments of multicoloured tiles. This gate, a true masterpiece of Catalan ironwork, provides us with the first indication of *art nouveau* in Gaudí's work.

Another feature of Gaudí's work on the estate was a free-standing staircase, now demolished, which was built above a complete parabolic arch. Gaudí had used such an arch, also demolished, for the fountain in the garden at Casa Vicens. At the Güell estate he used it for the entrance to the riding school, but there is no sign that it would become one of his most characteristic features, exquisitely executed in his next building, the Palau Güell, perfected at the Colegio de las Teresianas.

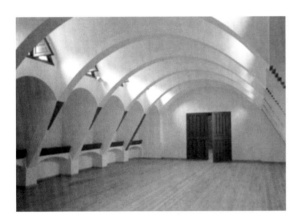 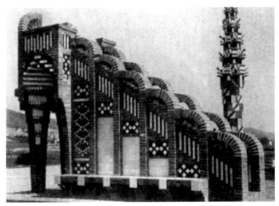

The interiors of the three buildings vary from the octagonal porter's lodge to the long flat stables spanned by a series of thick arching walls and the bare, light-reflective walls of the riding school. Yet outside there is the very visible Arabian influence, in the decoration of the walls composed of semi-circular terracotta elements. More importantly, where once Gaudí had relied for decoration on formally repetitive whole tiles, here is a free arrangement of tile fragments, chosen and placed to maximize the effect and reaction to the incidence of light, a feature that has since become one of the most internationally-recognised traits of his work.

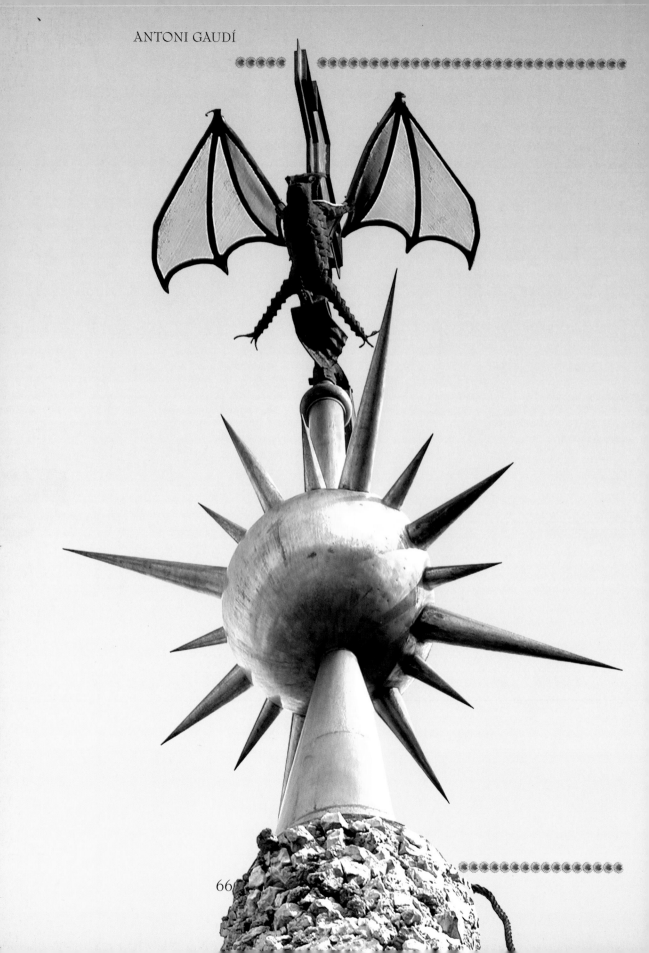

PALAU GÜELL

1886–1890

WHEN EUSEBI GÜELL COMMISSIONED Antoni Gaudí to build him a palace in the very centre of Barcelona, with no expense spared, it might be difficult to understand that this was to be on a small site about 16.5 x 20m (54 x 66ft) in a narrow street, in 1886 known as the Calle del Conde del Asalto, but appearing on maps today as the Calle Nou de la Rambla.

It took Gaudí twenty-five attempts at designing a façade that was to prove acceptable to his patron, and what was eventually agreed upon was surprisingly restrained, especially bearing in mind what the architect had produced hitherto. The façade of the Palau Güell is in the Venetian style, almost entirely lacking in surface sculptural features except for the elaborately-designed wrought-iron emblem of Catalonia that was positioned between the two large entrances at street level.

Perhaps of more architectural and historical importance are the Palau Güell's two magnificent examples of the parabolic arch. Gaudí finally proclaimed his deeply-held affection for this feature by placing them right at the front, on the pavement for all to admire. Furthermore, these great entrances are closed by

*Left: the weathervane-lightning conductor made of iron, brass and copper surmounts the conical spire on the amazing flat roof of Palau Güell at 3–5 Calle Nou de la Rambla, Barcelona. The building was declared a National Monument in 1969, and nominated as a World Heritage site by UNESCO in 1985, the first modern building to be so distinguished.
The building is open to the public every day except on bank holidays*

Below: one of the two oversized parabolic entrance archways and the Catalan coat of arms. The florid iron work over the gates shows yet more signs of Gaudí's emerging synthesis with **art nouveau**

openwork wrought-iron doors, at a time when the accepted convention was for wooden panels; thus again Gaudí was breaking new ground, setting new trends, and challenging the establishment.

Gaudí employed the parabolic arch design not only for the façade doorways, but also for the arches of the interior galleries on the main floor, though not in exactly the same proportions. However, these were

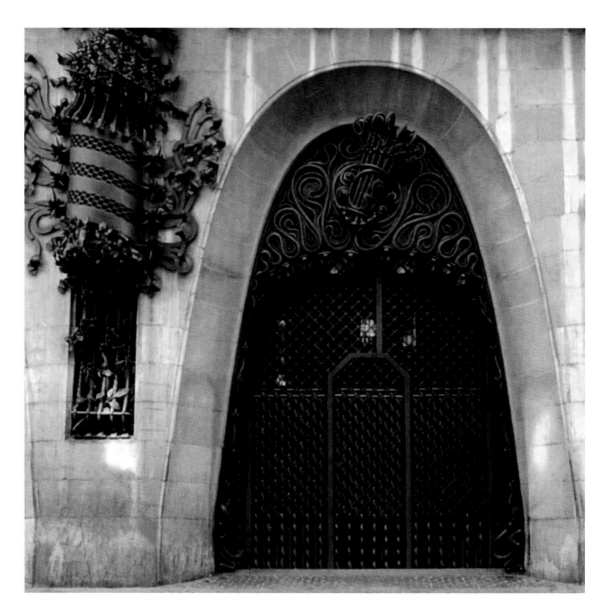

to become the designs that were to appear in all of his subsequent works, and which he later developed into a carrying element that would enable him to dispense with any flying buttresses in his Sagrada Familia.

The large entrances enabled carriages to pass through into the lobby, where any passengers or visitors could alight, and from where the horses could be led down a sloping spiralling ramp to the stables below. In addition to the stables, this sub-floor also provided accommodation for the grooms.

From the entrance lobby the main staircase leads to the first floor, where a transit room forms the centre of a gallery that runs parallel to, and overhangs, the street. From here two large doors give access into the large central room which forms the centre of the building, spanning three floors, reaching a total height of 15.85m (52ft). This exceptional room is crowned by a cupola, the surface of which is covered with hectagonal laminae of red-coloured alabaster and is perforated by a cluster of holes that simultaneously let in the light and give the impression of a starry sky.

This page: Gaudí used undressed grey stone from Garraf for the upper half of the façade. The lower half contains a narrow balcony and a symmetrical arrangement of horizontal windows. This building represents the darker side of Gaudí, shown in his use of wrought iron as the basic design element on this Venetian-style main façade

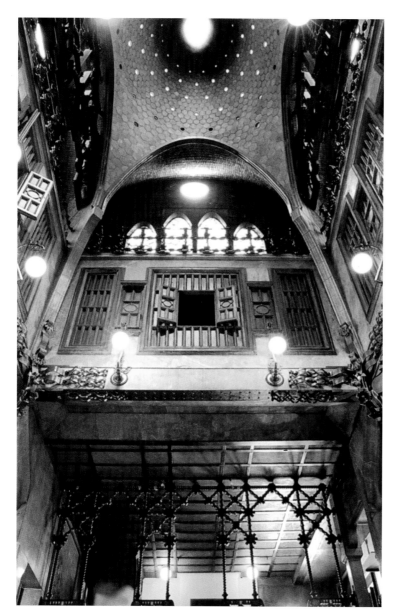

Left: Aleix Clapés, who had first been introduced to Gaudí by Eusebi Güell, worked as the architect's associate on the internal decoration of the house. He produced a series of oil paintings on canvas for this central room, which is the major socialising room of the house

Below: Palau Güell contains no fewer than 127 columns in total, throughout its six floors. The columns that run parallel with the façades in the front and rear galleries on the first floor are built in snake-eye stone from the Pyrénées

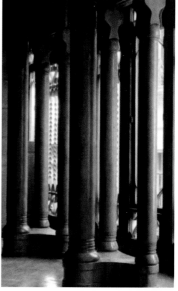

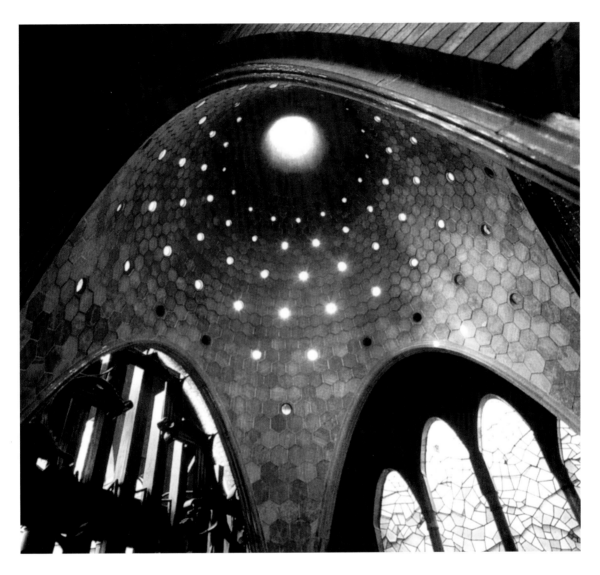

A rectangular space which runs parallel to the rear façade of the palace is divided into three by wooden louvred screens, to form the original dining room and a private family room. The central room of these three is a gallery, separated from the interior room by a colonnade of four parabolic arches supported on columns.

All of the important rooms in the house are lavishly decorated with wooden and wrought-iron ornamentation, with panels of eucalyptus and cypress.

Flat roofs are typical of Mediterrannean houses,

Above: the impressive parabolic dome of the central room is supported by four transverse rib arches

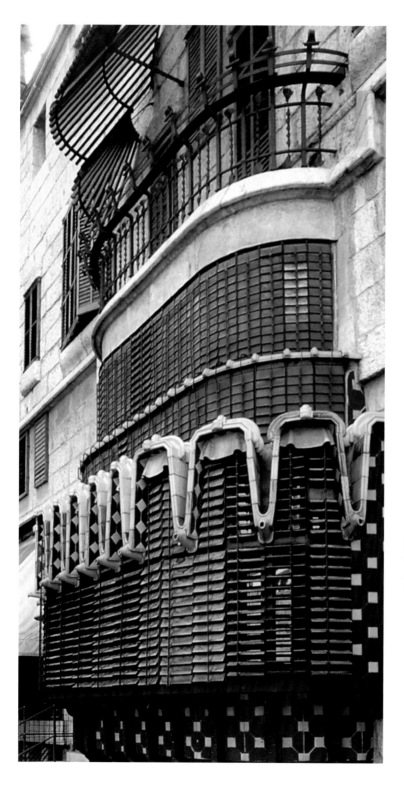

Left: *the rear façade contains a bay window, behind which is a colonnade of four parabolic arches on the first floor, supported by columns*

Below: *large oak doors give access to the old coach houses, from where the main staircase ascends*

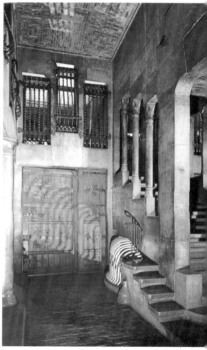

Below: William Morris, whom Gaudí had met, and Henry van der Veld had promoted the concept of using craftsmanship in the creation of an integrated environment. Gaudí was deeply interested in crafts, and tried for the first time at the Palau Güell to unite them. He designed some of the furniture for the house, including the mirrored table below, but he was conscious of his own limitations in terms of time and ability and so he employed the services of other artisans such as Aleix Clapés

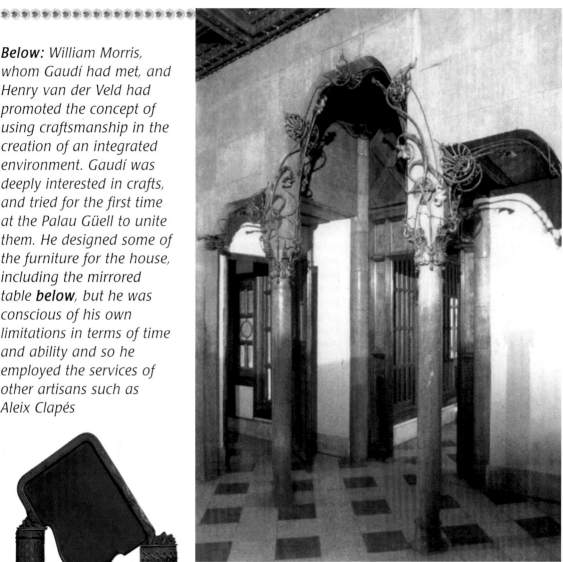

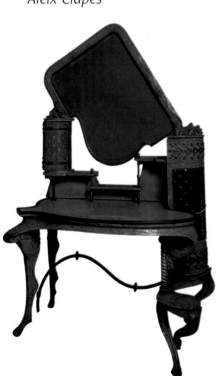

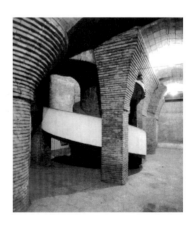

Above: the entrance leading to the principal bedroom of the Palace

Right: the hallway descends via a beautiful helicoidal stairway to the stables below

but Gaudí conceived them as a most important element of his buildings and he allowed his imagination to create a fantastic wonderworld open to the sky, where varigated shapes are free to rise up from their tiled base. The roof of the Palau Güell is dominated by the small cupola which is set above the central hall. Gaudí turned this into an unusual conical spire, like a witch's hat, which is flanked by four shell-shaped lunettes and crowned by a combined weathervane and lightning conductor made of iron, brass and copper.

The remainder of the roof is dotted with twenty beautifully-decorated or exposed-brick sculptures, which are disguised chimneys and air ventilation ducts. Thus, from top to bottom, Gaudí created a very special building, a sumptuous individualistic palace, which furthermore was a building that proclaimed (literally from the rooftop) the arrival of an important new architect.

The flat roof of Palau Güell is on two levels, with 14 of the 20 chimneys, together with this spire, on the lower level. Tiles from the original period or reproductions from the same manufacturers were used when the chimneys were restored in 1992, and in some cases these pieces were made using traditional methods.

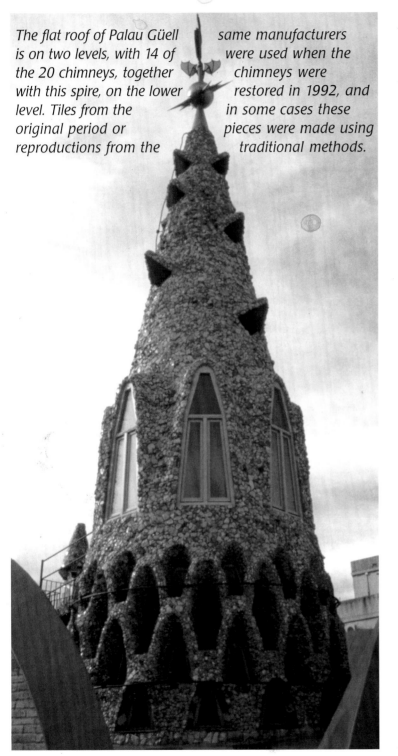

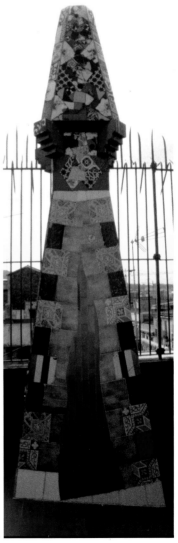

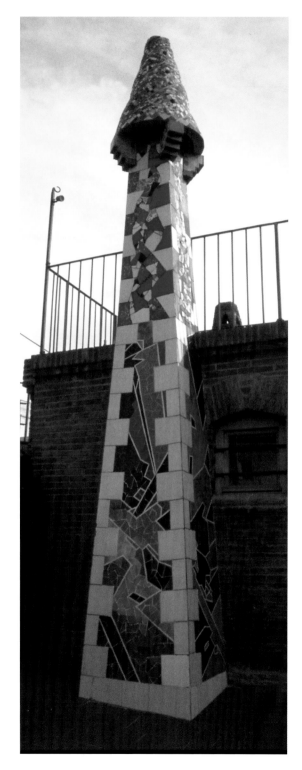

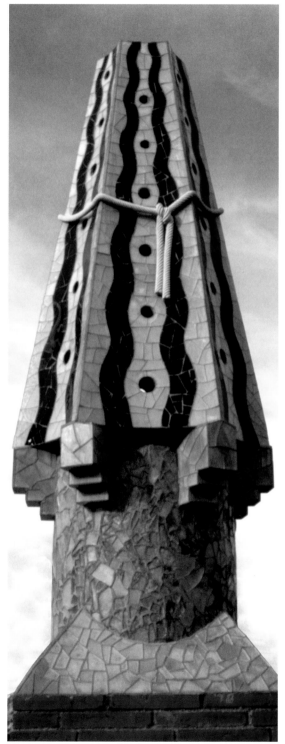

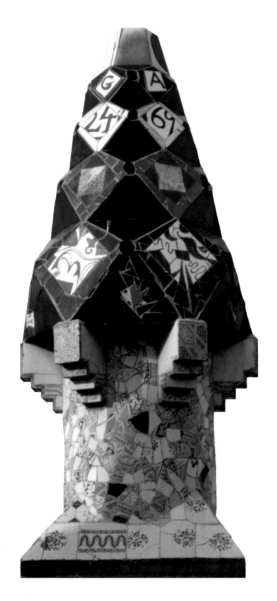

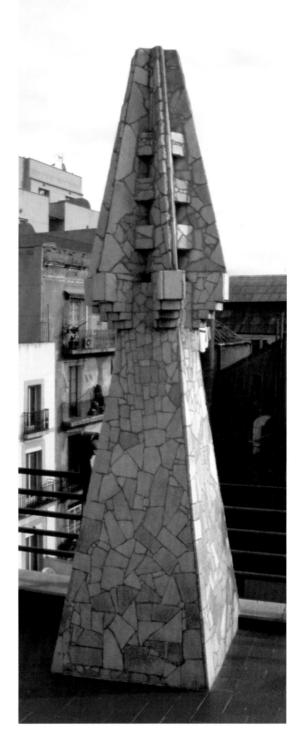

The bases, shafts and cowls of the fourteen chimneys on the first floor roof level are all different in shape, as are the materials used to face them. Trencadís, fragmented tiles, are used on eight of the chimneys, and earthenware for one, marble for one, glass for three, and vitrified sandstone from the inner lining of old lime kilns for the last chimney and the spire

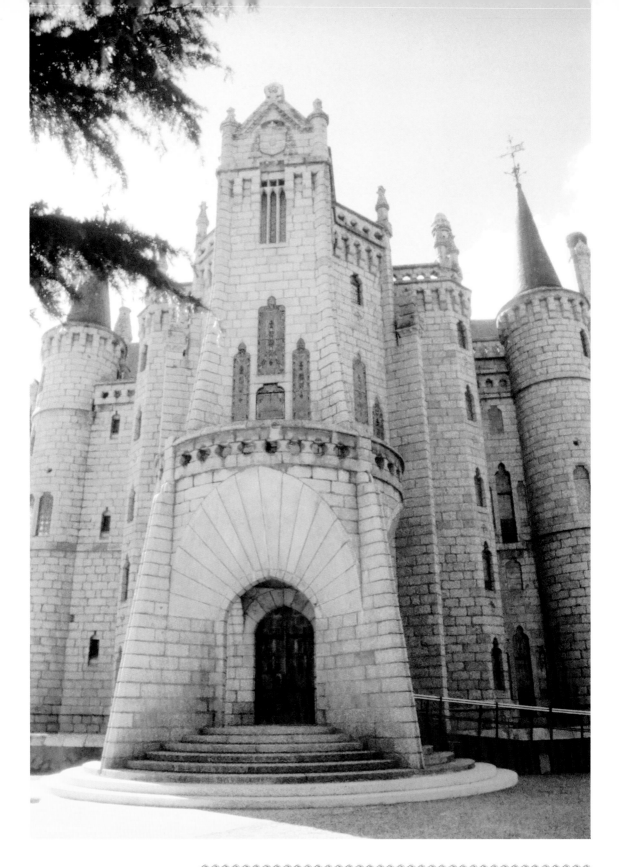

PALAU EPISCOPAL

1887–1893

THE BISHOP'S PALACE AT ASTORGA is an inspired work of gothic fantasy. It was planned while Gaudí was building the Palau Güell in Barcelona. Although it was thus not the ideal time for the architect to receive the commission, he agreed to accept it because of his religious leanings and his strong Catalan loyalties.

Gaudí started by requesting exact plans and photographs to be sent to him of both the site and its surroundings, Astorga being an important old walled city on the pilgrims' route. From these he produced the plans which, unexpectedly, were to delight the bishop. Members of the San Fernando Academy in Barcelona, who also had to approve them, had reservations, however.

Eventually Gaudí reached an impasse with this body, which resulted in his withdrawal from the building work in 1893, before it was finished. Twice before this, he had been forced to amend his plans to comply with the objections of the Academy members, who insisted on precise drawings. Perhaps this was not altogether unreasonable, but it was anathema to the way in which Gaudí had grown used to working, although he had complied with the Academy's wishes on the earlier occasions for the sake of his friendship with the bishop.

The new architects altered the plans, with the

Left: after the original bishop's palace had been destroyed by fire on 23 December 1886, Gaudí was approached to prepare plans for its restoration by Juan Bautista Grau i Vallespinós, the bishop of the diocese, soon after the fire but during the following year. Unfortunately, the bishop died, and Gaudí had to abandon Astorga owing to increasing disagreements between himself and the episcopal authorities

result that part of the building collapsed, following the departure of Gaudí and of the Catalan workers whom he had originally taken with him to Astorga because they had become accustomed to his idiosyncratic ways of working. The building was finished at last, in 1961.

A characteristic of Gaudi's neogothic style is his efficient use of space. The design was built with white granite outer walls, and Gaudí planned to complete the effect with a white roof. He used French gothic capitals for the columns inside, and star-shaped abacuses (flat slabs on top of the capitals, supporting the architrave)

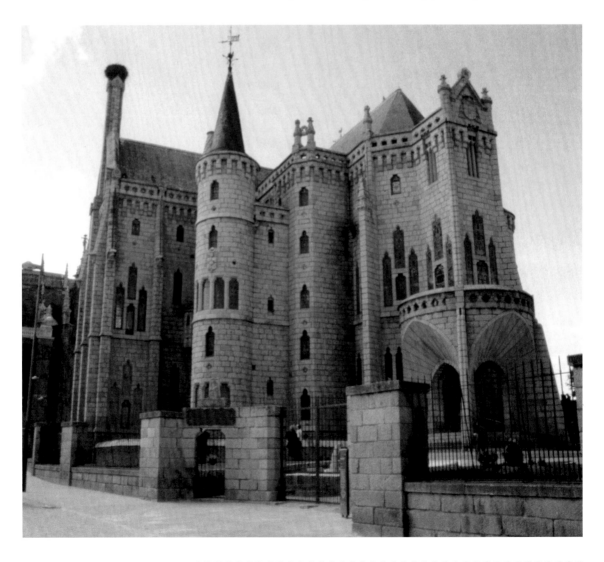

Left: *Bishop Grau had previously been the Vicar-General for the Archdiocese of Tarragona, and had been born in Gaudí's home town of Reus. Following his death and Gaudí's departure from the project the building was completed with roofs that differ from the original design. The bishop's palace was never inhabited by the bishops, and is now open as a museum*

Right: *a window from the palace which betrays a very clear **art nouveau** link, featuring the rosebuds which were almost certainly copied by Charles Rennie Mackintosh as a recurring element of many of his designs*

that he copied from the Sainte-Chapelle, Paris. There are other gothic traits, especially in the first-floor dining room.

Today the two zinc angels, that originally had been intended for the roof, flank the approach to the entrance. The Palau Episcopal is now one of the most esteemed monuments in western Spain, an inspired work like a fairytale castle in a wonderful setting.

COLEGIO DE LAS TERESIANAS

1888–1889

THE COLEGIO DE LAS TERESIANAS (Teresian School), Barcelona, is by far the most interesting of Gaudí's work of the period. It represents the development of a precise and extremely clear architectural ordering of gothic motifs externally, in contrast to the white cloister-like corridors with their perfect parabolic arches inside to create a feeling of absolute tranquillity, far removed from his normal energetic and colourful works.

The school is the epitome of harmony in brick and masonry. The entire exterior has a rhythmic flat patterning of tightly-spaced narrow windows, complemented by their beautiful iron railings on the ground floor and arched wooden shutters above.

Here, Gaudí did not have a wealthy sponsor with unlimited funds; money was important on this project, especially as the order of St. Teresa had made frugality one of its prime commitments, and thus Gaudí should

Left: the spire over the right corner of the front façade of the Colegio de las Teresianas, which is surmounted by a horizontally-mounted ceramic cross

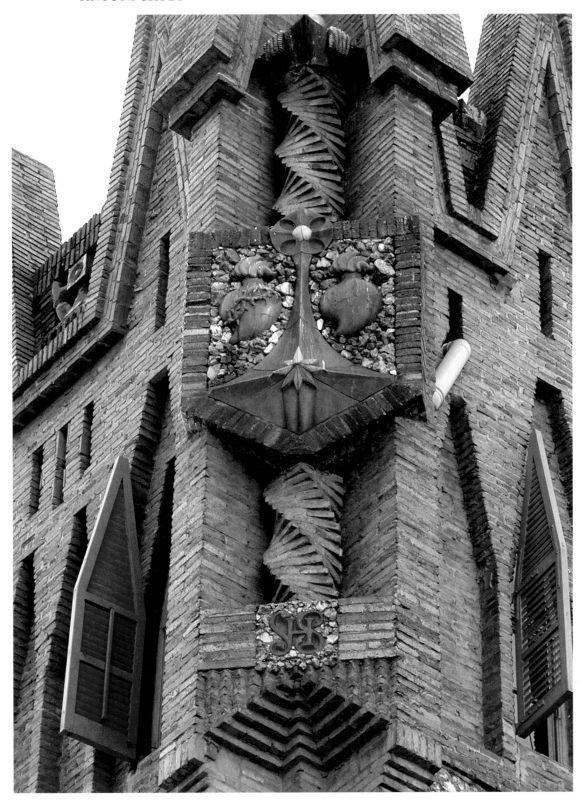

Left: *below the spire with its ceramic cross the angular turret is emblazoned with the coat of arms of the Carmelite order, below which is one of the many anagrams that Gaudí employed to refer to Jesus. The coat of arms consists of the cross on Mount Carmel between the hearts of the Virgin Mary and St. Teresa*

Above right: *the bell tower, which is positioned halfway along the top of the façade on the right-hand side of the building. Note the cross which is tucked away underneath the bell; such crosses as this appear within each of the crenellations along the façade*

Below right: *one of the architect's 127 references to Jesus that are distributed throughout the school, many of them being well hidden. This anagram is in a brick surround; others appear in the ironwork bars to the windows, while others like that on the facing page are on a pebbled background*

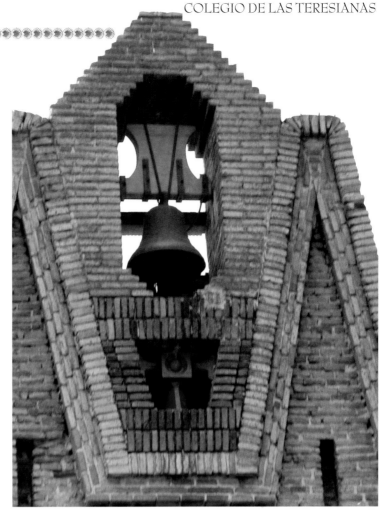

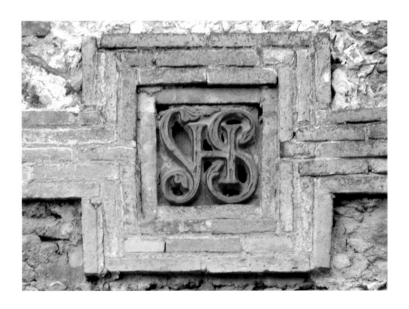

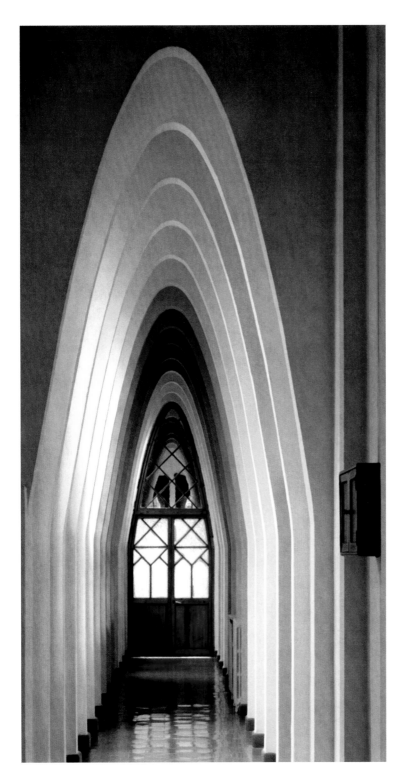

Left: *one of the cloister-like corridors of whitewashed parabolic arches*

Right: *one of the first-floor corridors, which has whitewashed surfaces in between the brick supports, that were designed to echo the brick parabolic arches used throughout the building. They are a slight variation on the beautiful clean arches with which Gaudí was able to create the impression of spartan sobriety that is so suited the function of the building*

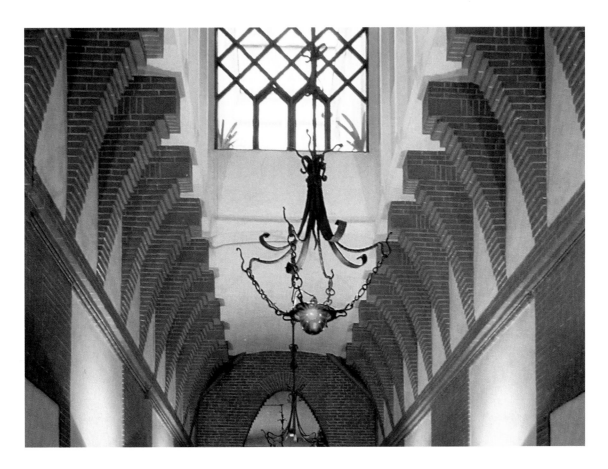

be applauded for adhering to the budget though his employers complained about the expensive bricks.

By the time Gaudí had become involved in the project the first floor had already been built and he was therefore forced to accommodate the entire, strictly rectangular, shape of the ground plan in his scheme.

The ground plan divides the building lengthwise into three narrow sections which run parallel to each other. The basement of the middle section includes a long narrow corridor, above which, on the ground floor, rectangular inner courtyards allow sunlight to enter the inward-facing rooms. To enable an arrangement whereby these inner courtyards are continued on the upper floors, Gaudí amended the supporting structure from carrying walls to long, cloister-like, corridors with single rows of identical symmetrical arches.

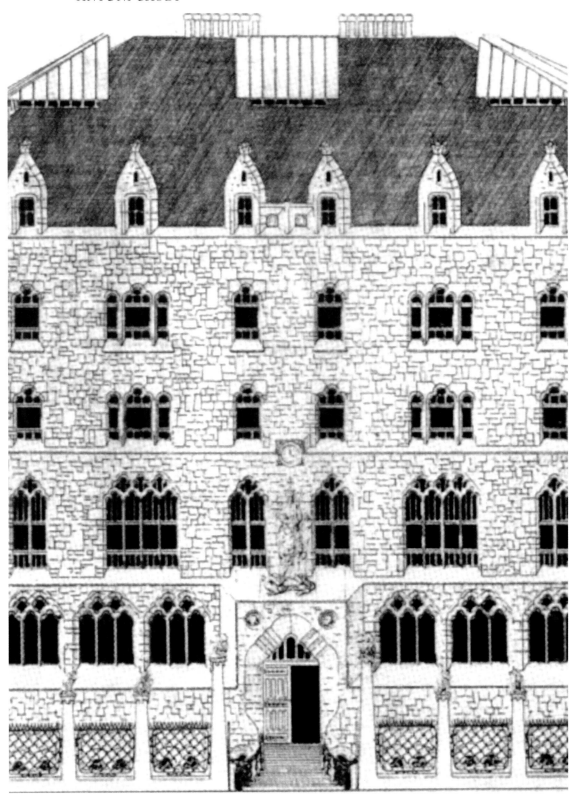

CASA DE LOS BOTINES

1891–1892

WHILE GAUDÍ WAS LABOURING on the Palau Episcopal in Astorga, he was asked to design a business and apartment block in León. Standing on the Plaça de San Marcelo, it was known as Casa Fernández y Andrés (after the first owners, Simón Fernándes and Mariano Andrés) but is now Casa de los Botines, for the father of the financial backer of the project, Joan Homs i Botinàs. It was developed as a compact block in white granite with neogothic lines, and with the Palau Episcopal, Astorga, and the Colegio de las Teresianas, forms a series of gothic-inspired Gaudí buildings.

The main entrance on the ground floor, which houses retail outlets and offices, is approached via a flight of stairs and a wrought iron gate. The four corners of the building are turreted in the manner of the bishop's palace, but here they do not take up the full depth of the façade, being curtailed at first-floor ceiling height.

Left: the central portion of the front façade, with a statue of St George the dragon slayer above the entrance. Iron railings surround the building. It is well lit by a continuous band of windows with rounded tops in triforium form. Its semi-basement storage area has a series of half-windows; there is less window space on the first floor, and less again on the next two floors and the attic floor which house the apartments

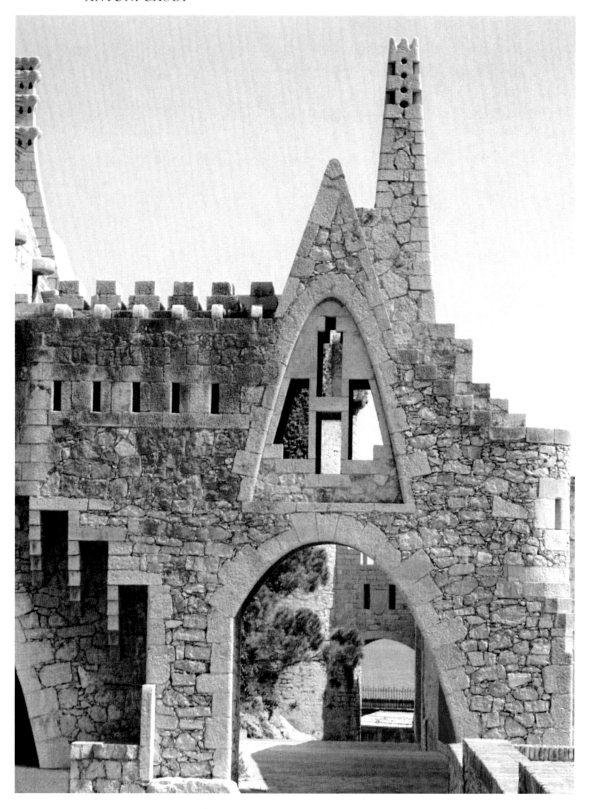

THE GÜELL BODEGAS

1895–1901

THE WINE CELLARS on the outskirts of Garraf were originally attributed to Francesc Berenguer i Mestres, but as they do comprise a series of quite contrasting architectural forms, it is now widely accepted that at the very least Gaudí cooperated on the project.

Such characteristic elements as the parabolic arch, which was perfected at the Colegio de las Teresianas, is used here for both entrances and window spaces. Catenary arches, such as those featured at the Güell estate stables, are also employed throughout, and there is the entrance gate of iron chains. This has a similarity to the Güell estate dragon gate, being also a single large unit hinged on one side only.

The structure itself is built into the hillside, and constructed primarily from local stone and brick. It is arranged with the wine cellars below, above which are the living quarters, and above them a chapel. The entire building is capped by a roof that is designed in the shape of an arch which almost reaches the ground on one side, and although this may look like an A-frame of barn proportions it is still very much in the Gaudí idiom.

Left: Gaudí used arches similar to the wooden arches he first employed at the factory of the Cooperativa Obrera Mataronense for the main building, which lies to the left of this picture and has now opened as a restaurant. He also used parabolic arches structurally in the walls at the side of the building shown here, for example where the wall acted as a retaining wall, and for doorways lower down the building in the storage cellars proper

CASA CALVET

1898–1900

Casa Andreu Calvet i Pintó at 48 Calle Caspe, Barcelona, was designed so that it could also serve as a commercial premises on the ground floor with apartments above, like the Casa de los Botines. As such, the building represents Gaudí's most conventional work to date.

The building is constructed in large blocks of undressed stone from Monjuic, a mountain in Barcelona. It is abutted on each side by other houses, and comprises five floors above street level, plus a basement. The symmetry of the façade is created by the organisation and carefully judged proportions of the windows and balconies, as well as by the arches on the ground floor.

As at León, the basement was intended as a storage area, the ground floor for retail outlets and business premises, and the eight apartments filled the remaining four floors. The house is a relatively simple building, at the heart of which is a stairwell surrounding a lift shaft, between corridors running from the front to the rear, the purpose of which was to provide light.

Left: a first-floor window with iron railings on the far right of the front façade of the Casa Calvet, by Gaudí. The architect received a prize, the Barcelona council architecture award, for this, which was the only official recognition of his work within his lifetime

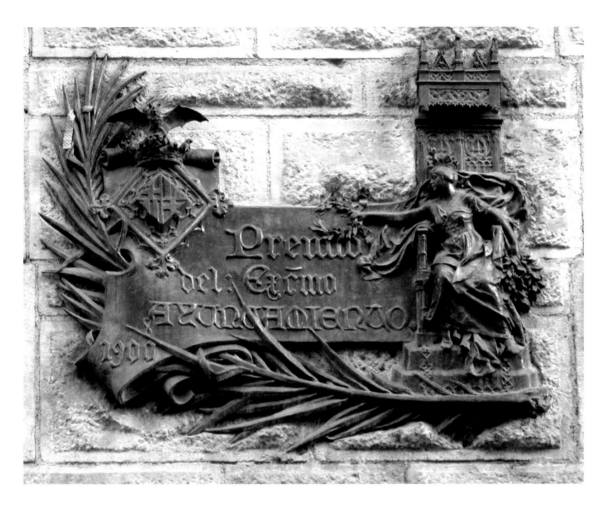

Left: the upper pediment (left side only illustrated) of Casa Calvet, which exceeded the permitted building height for the city of Barcelona, is crowned by two iron crosses, each on top of a stone sphere, under which is the completion date of the building. Within the pediment are two iron hoists made by Lluís Badia, to aid the delivery and removal of furniture. They are interspaced between the busts of three martyrs who look down on the pavement below. The busts are those of St Peter, in the centre; St Pere Mártir, in honour of the proprietor's father, Pere Mártir Calvet, who was a citizen of Vilassar the village where the proprietor was born, and St Ginés, who had been born in that village also

Above: a plaque, positioned beside a window on the first floor, announces the architecture award from the city council for the first-ever prize for a new building. It is dated 1900, this being the year in which the prize was awarded. Gaudí had originally intended to fill the doorway with a drawbridge, which was never built

Right: the upper pediment and balconies of the house of Pere Mártir Calvet, an industrialist from Vilassar de Mar who had made a fortune in the textile trade, but who fell into financial ruin and was forced to sell the house in 1927. He became a tenant in it, paid his last rent bill with a few belongings, and died penniless

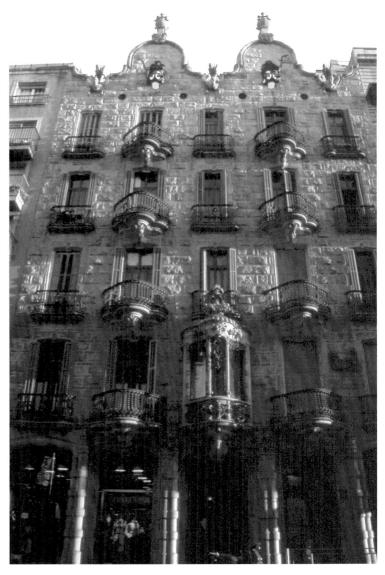

Left: Gaudí designed the furniture for both the apartments and for the offices, including the desks and chairs

The building also boasts a solitary, huge, almost baroque oriel placed above the main entrance, right in the middle of the building. This is in perfect harmony with the surrounding windows, of which there are nineteen. Their alternating flat and outward-curving balconies play rhythmically across the flat façade.

Gaudí designed a number of columns in different stone, all with elaborate capitals, for the central hall. He also designed the two columns that flank the main entrance and which are carved to represent textile bobbins, a reference to the owner's industry. Throughout the building Gaudí secreted his little ornamentations referring obliquely either to his beloved Catalonia, or to his patron, such as the wild mushrooms that are formed in iron and combined with stone flowers as a reference to Calvet's deep interest in botany.

The walls of the stairwell are tiled in bright blue, their pattern a swirling flower motif which suggests echoes of the illustrations of William Blake. Above the tiles, and around the doorways with their stone architraves, there are also painted floral designs.

*Left: an oak seat designed by Gaudí for Casa Calvet, in 1902. The architect designed more furniture for this building than for any of his previous houses, including chairs and seats in polished oak. All of these were designed with the human body in mind, and had a definite **art nouveau** flavour. He also paid particular attention to the inner doors and other joinery, for which he employed the services of the carpenter Casas i Bardé, who also worked on the decorative wooden ceilings throughout the house. The fixtures and fittings which Gaudí designed include peep-holes for the apartment doors. These are said to have been designed by the architect by sticking his finger into soft plaster, to create a mould for the brass. Wrought-iron elements include the elevator cupola and the stair railings*

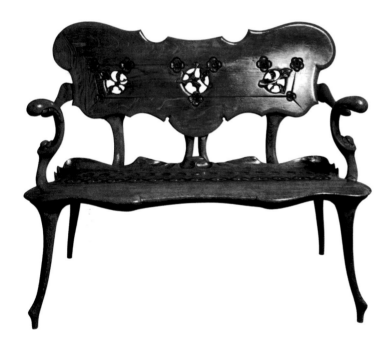

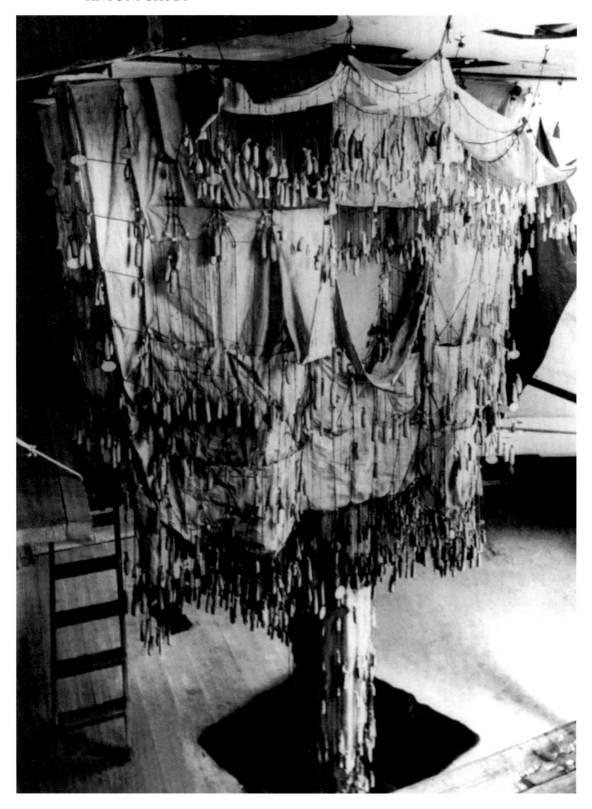

GÜELL COLONY CRYPT

1898–1917

THE CRYPT OF THE UNFINISHED CHURCH in the Colonia Güell, Santa Coloma de Cervelló, in the lower valley of the Llobregat south of Barcelona, contains the clearest example of Gaudí's ingenious solutions to the understanding of stresses. Here, he overcame the structural problems of achieving a static equilibrium which enabled him to create a freer, less regimented, structure that was not restricted to straight lines and right angles and so appeared more natural.

The chapel, planned for the Güell textile factory workers, even though it was unfinished represents the greatest achievement of Gaudí's investigations. Here, at Santa Coloma de Cervelló, Gaudí freely applied his new methods, and learnt how to circumvent the established conventions of gothic composition, in order to mimic organic forms of growth. He discovered a natural link with the archaic and the classically pure forms that possessed an intense dramatic expression.

Left: a reconstruction of Gaudí's funicular model. This preliminary three-dimensional diagram for a new project was created on a ratio of 1:10,000, as a means of calculating the exact pressure that each pillar and arch would have to bear. In order to make one, Gaudí suspended from his workshop ceiling a network of cords, each of which represented a catenary arch. From them he hung small drawstring bags that were filled with buckshot to represent weights, in proportion to the predicted weights for the vaults. The bags could be moved along the cords, some bags added or removed or the weight in a bag adjusted, as his ideas or calculations changed. He photographed the model, turned the photograph through 180°, and used it as the outline on which he traced the image of the building in gouache on the photograph. These paintings served as drafts for the three-dimensional models, none of which have survived, for the buildings that he was planning

The preparatory studies, made with his funicular models like that illustrated facing the previous page, allowed him to experiment in making calculations of the forces and weights that determined the correct angle of inclination of the columns and pilasters. These columns were thus transformed into the essential elements of his fantastic invention. His achievements with the integrated use of different materials (stones, bricks, cement, iron, enamel, and glass) in a variety of colourations are an important part of the whole effect, unifying elements, not just decorative links.

We may infer from that which remains (a few rough gouache sketches that Gaudí made from the

Below: the interior of the crypt, where the slanting columns are built of brick and basalt

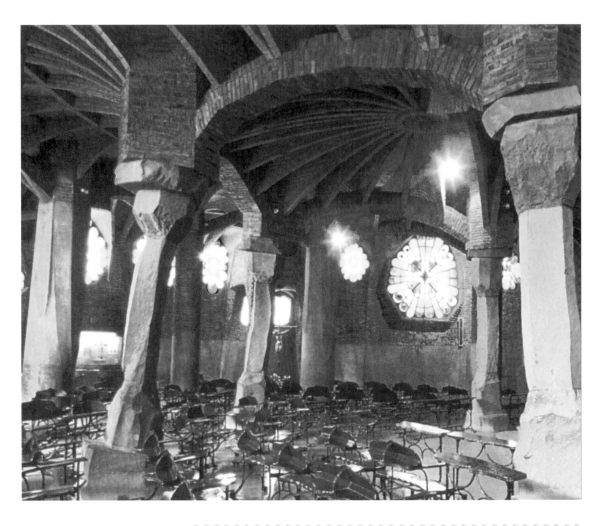

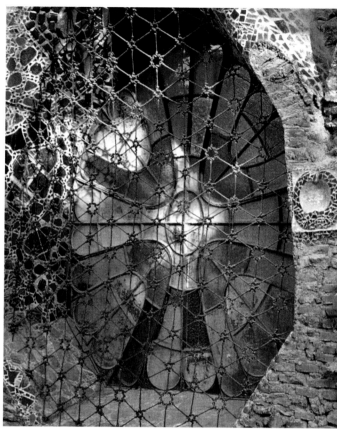

model), that the style of the church anticipates that of the Sagrada Familia. It has a series of towers, it relies on the parabolic arch design, and, more importantly, its foundation is based on an arrangement of slanting pillars. This foundation, the crypt, has been built on the upper part of a low hill, and is approached via a large vestibule which is supported by a hall of brick and basalt pillars that simulate a pine forest. Some of the bricks are circular, and had to be specially made.

The vault, like that at Parc Güell which is supported by Doric columns, functions as both ceiling and floor, and is a composition of numerous brick arches, some radiating from a point above the altar, while a U-shaped hall surrounds the chancel. The whole effect is one of joyous natural perfection, albeit in just a small completed part of the intended large church.

Above left: this vault keystone depicts a handsaw. This is a reference to Joseph, who is the patron saint of the Sagrada Familia

Above right: windows in the crypt which take on nature's forms are protected on the outside by grilles wrought from discarded weavers' needles

Below: a view of the upper side façade and roof of Bellesguard. Its tall tower is to the far right of the illustration; the gabled attic windows project from a slate roof, above parapets that appear to have been borrowed from a medieval castle

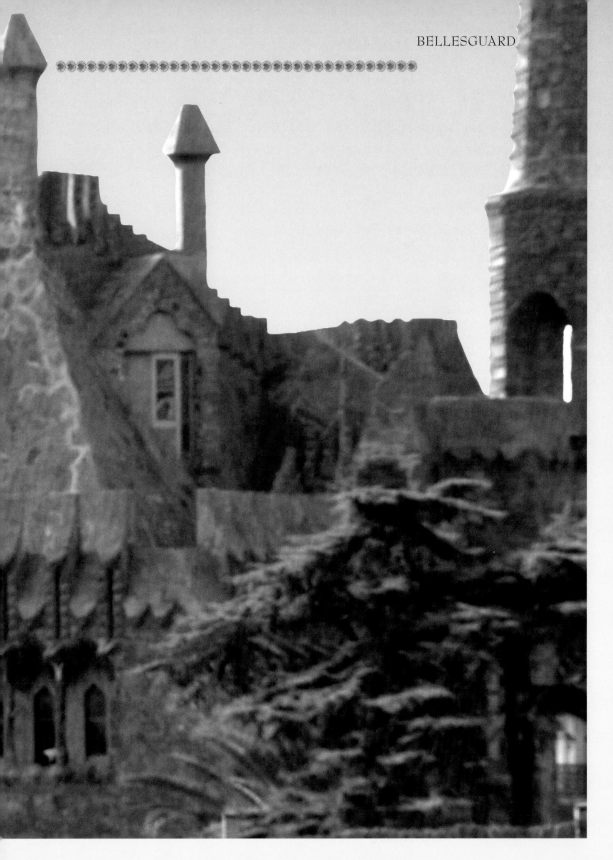

and the iron gate, although in keeping with the window bars, is so lacking in ornamentation that it is far from what we have come to expect from Gaudí.

However, as always Gaudí has filled the building with his oblique references, in this instance to the Middle Ages and to the past glories of his beloved Barcelona. There are pointed gothic arches; a pointed, almost medieval tower on one corner, and on the façade Gaudí's interpretations of crenellations and a rampart-like parapet that encircles the roof.

Bellesguard's tower, with its very slender high steeple, is crowned by a typical Gaudí four-armed cross. While the building's wide array of uniformly-arranged windows provides an almost fluid aspect to the surface, internally the arrangement is one of sharing columns,

pilasters and arches such that any architect might be expected to avoid rather than to create.

In the basement a series of squat pillars supports a vaulted ceiling, which is built in undressed brick. The ground floor above is also covered by thin brick arches, and the internal walls are strengthened by iron bars, but here Gaudí coated them in whitewashed plaster. This use of white is relatively unusual in his work, but it does echo the fluid appearance achieved on the exterior by means of the windows, because it appears to make the rooms flow into each other. It could be seen as the precursor of the wavy structure used in the Casa Milà.

Bellesguard has two attic floors, which are on the second and third storeys; the second floor is one large airy hall, the space being achieved by the use of carrying arches. The room becomes filled with light from the tall narrow windows. The smaller top attic floor is illuminated by four gable windows, and is reached via the staircase which begins inside the tower on the lower floors, but which then climbs behind the tower to the two attic floors. Gaudí added colour to the interior in this stairwell, by his use on the lower part of the wall of ceramic tiles of a typically Catalan design.

During the later phase of the building work, Gaudí was asked by the owner to place a lightning conductor on the top of the very tall and slender spire. The architect argued against this, insisting that it was not necessary since lightning had never fallen on the area and that it was unwise to tempt fate. Fortunately the will of the owner prevailed and the lightning rod was installed just a few days before a thunderstorm broke, and the house was struck by lightning.

However, this incident had nothing to do with Gaudí's desertion of the unfinished project, a tendency that he had displayed before. In this instance he stopped work in 1909, on the date of the five-hundredth anniversary of the marriage of Martí I of Aragón, the last king of the House of Barcelona, to Margarida de Prades at Bellesguard. The work on the house was completed by Domènech Sugrañes in 1917.

Left: the gate to Bellesguard does not conform to our preconceptions of the work of Antoni Gaudí, but it was in keeping with this transitional work. The pikes on the top of the bars are very medieval in style

The coloured glass section of the window that is sited above the main entrance is in the shape of an octagonal star; **left,** as seen from inside and, **right,** the external aspect. The image is said to represent Venus, the goddess of love

Below: mosaic benches by Domènech Sugrañes flank the main entrance; the crowned fish motif refers to the city of Barcelona when it had been a great maritime power

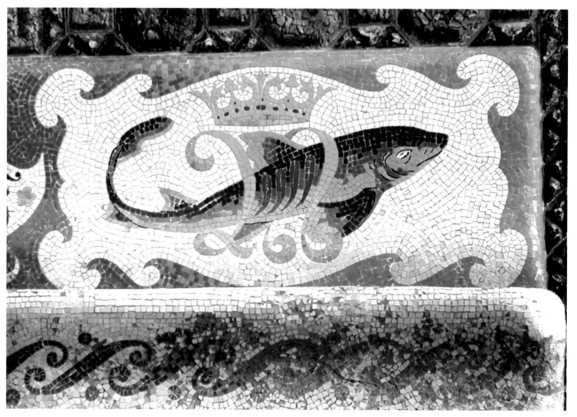

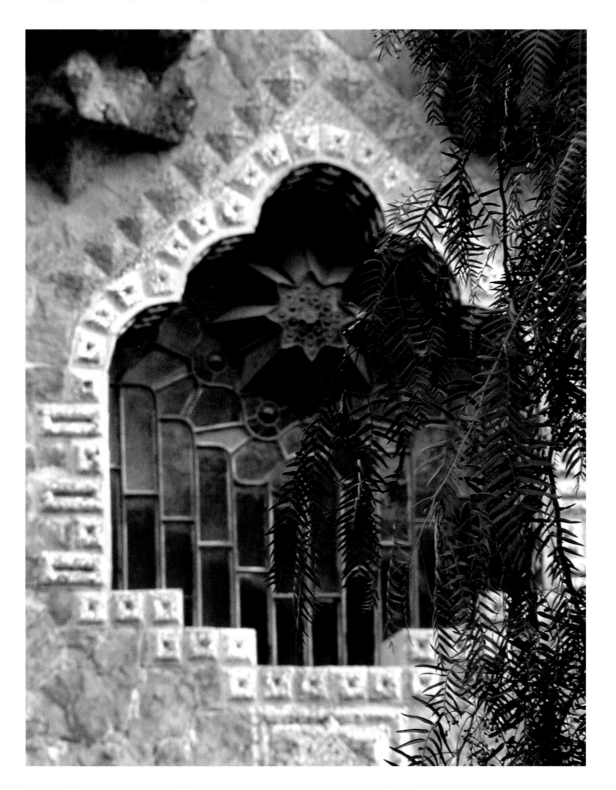

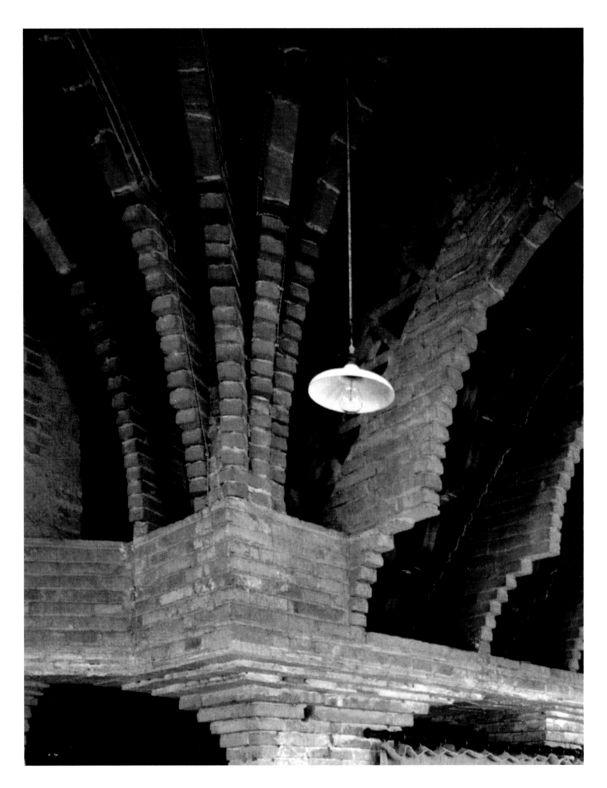

*Left: slender ceiling arches of unglazed bricks on the attic floor contrast markedly with similar thin arches when they have been plastered and whitewashed, as they are over the stairs, **right***

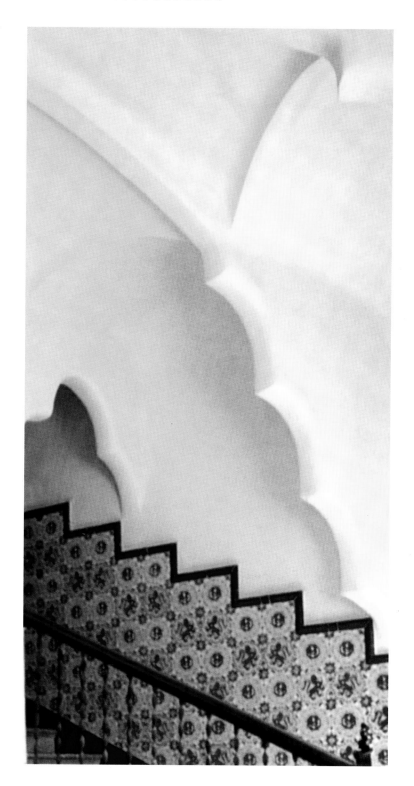

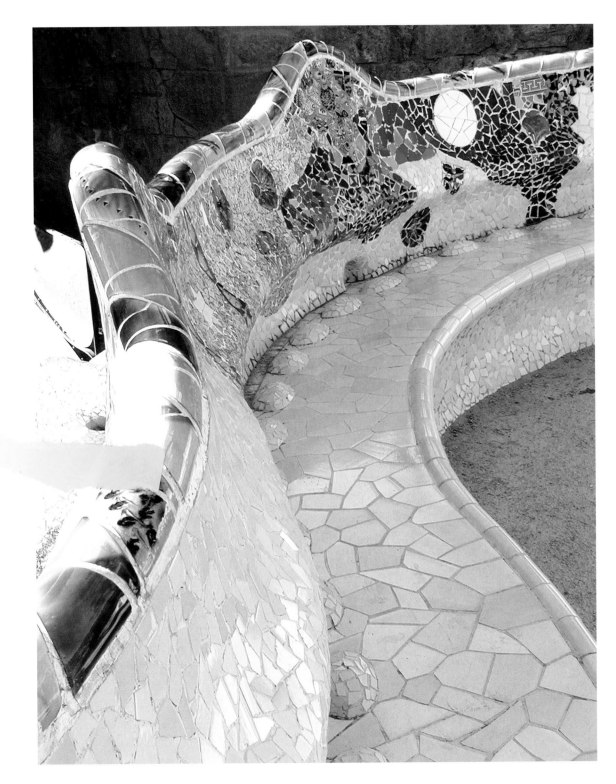

PARC GÜELL

1900–1914

UNQUESTIONABLY ONE OF GAUDÍ'S most prestigious and internationally acclaimed works, Parc Güell was created on the ideal site, then known as Muntanga Pelada, at the bottom of the Tibidabo hill, where it overlooks the city and beyond that to the Mediterrannean Sea.

The park was laid out because of a desire by the city council for the creation of green spaces, but the original plan that proposed a model garden city with about sixty houses surrounded by gardens was rejected. By then Gaudí had already designed and built the infrastructure and services for a luxury residential area, but once the plans were rejected the park was given to the city as a public place.

Parc Güell covers an area of about 56 hectares (138 acres) of land, through which run roads, viaducts and a variety of footpaths, all of which were designed to exploit the natural characteristics of the hilly landscape to the fullest possible extent. This area was a barren rocky hillside, devoid of all growth, before Gaudí was set to work.

There is no element of this fantasy park, which is a lesson in synthesis between architecture and nature,

Left: benches at the Parc Güell snake away, their colourful patterns a solid serendipity in the Mediterranean sun. The benches, which are faced in mosiacs of broken tiles, were designed as a cooperative effort between Gaudí and the workers employed in the building of the park. The effect is wondrously beautiful, eminently practical and completely unique. The Park has been declared part of the World Heritage by UNESCO, which placed it under an international preservation order in 1984

*Overleaf: a typically Gaudí gate protects the main entrance to the park, the name of which is emblazoned in mosaics on medallions, **inserts left** and **right***

Below left: the office building, with its 9m (30ft) high hollow turret surmounted by a cross, was reinforced by Gaudí with 10mm (0.4in) thick iron rods, and lies to the left of the main entrance to the park

Below right: the porter's lodge, on the opposite side of the entrance to the office, is apparently topped by a poisonous toadstool; the two buildings were designed to portray the story of Hansel and Gretel

that was not fully thought out and constructed on a well-reasoned basis. The structures within the park were built almost entirely from materials that were available on site, which is as economical as possible, and which may be considered at odds with the architect's tendency to overspend his budget. Gaudí felt strongly that by using what was to hand, it should be possible to make the structure harmonious with its surroundings. His daring technological solutions are everywhere evident; his exploitation and use of the surroundings, all his radiant, parabolic and agglutinative forms, where the elements are combined without losing their independence, are there.

At the main entrance to the park are two coloured access pavilions, part of the original plan, their ceramic decorations reflecting the light throughout the day. The pavilion to the left, which now acts as the office building, is topped by a tall slender blue-white steeple. That on the right of the entrance is the original

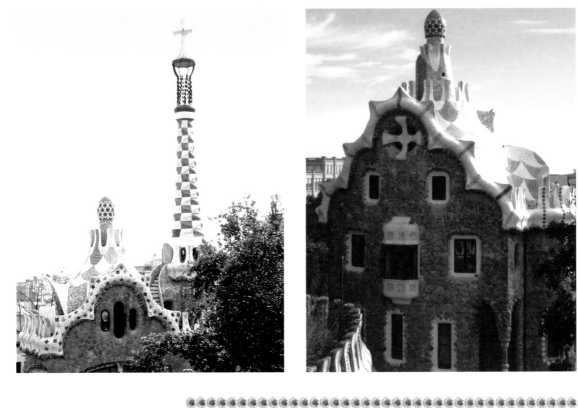
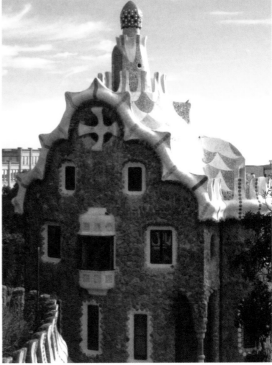

porter's lodge, and it is also crowned by a ceramic roof, above which is a beautiful toadstool chimney. Both of these small buildings were constructed in undressed stone and are incorporated into the park wall.

The entire area, which Güell intended to become the second largest park in the city, a Utopian estate of houses and gardens, has been in public ownership since 1922. It is encircled by a perimeter wall; fitting in closely with its natural environment, this snakes its way around the park, and is adorned all along the top with a typically Gaudí mosaic of brilliant colours. This wall is broken only by the seven entrance gates to the park.

Once inside the main entrance gate the visitor is confronted by an outside staircase which climbs up on each side of the park's famous brightly-coloured lizard, Python, the guardian dragon of the subterranean waters. According to Greek mythology, Python was a monstrous she-dragon which inhabited Delphi before the coming of Apollo, and gave the place its first name,

Below: *gates leading to the school playground, from halfway up the stairs. The school now occupies the building that was once an old family residence of the Güells, before the park was created*

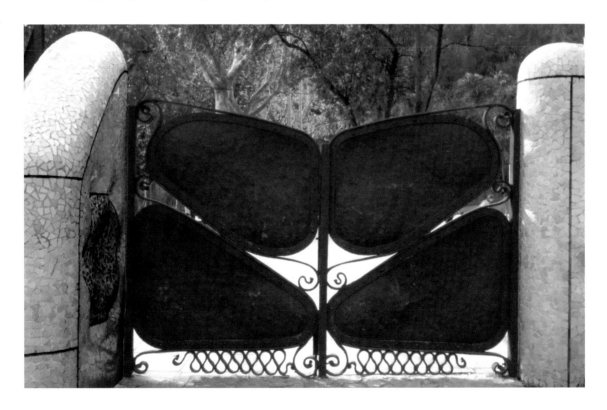

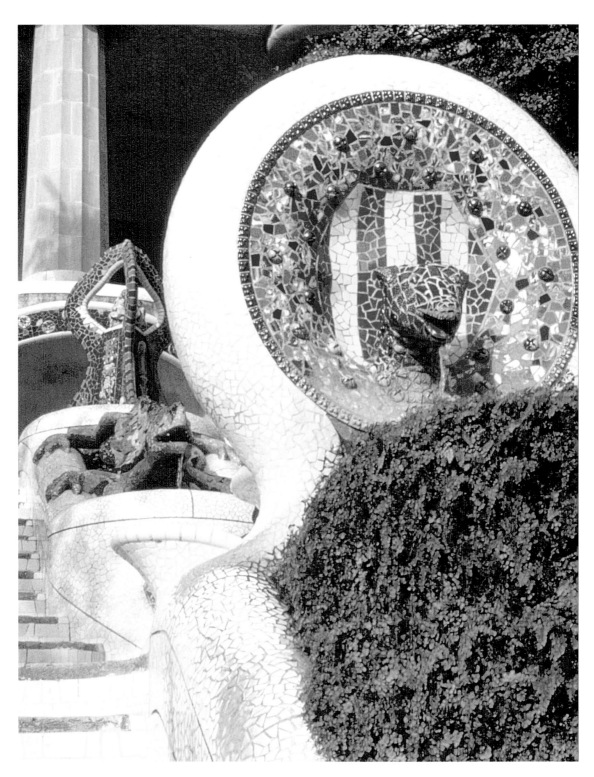

Pytho. She was usually thought to be the guardian snake of the original Oracle there, belonging to Gaia (Earth). When Apollo came to Delphi to establish his oracle he shot the great serpent, after which Apollo's prophetess at Delphi was always known as the Pythia.

However, placed centrally in front of the dragon is a snake's head. Its mouth and the mouth of Python are both used as overflow valves for the cistern that lies buried behind them. The importance and the hidden significance here are that the park was originally a dry and barren hill devoid of vegetation, and even if it had been developed into a garden city there would always have been a water supply problem. Behind Python, Gaudí concealed a cistern with a capacity of almost 12,000 litres (2,600 gallons), which was there to collect the rain water. This could be used to irrigate the park; originally, sixty triangular allotments had been planned.

The main stairs, having divided to rise on each side of the ceramic lizard, meet at their top to spread

Left: the architect was proud of his Catalan heritage, and to symbolise this pride and the city of Barcelona's maritime history, immediately in the front as you enter the park he placed one of his frequent allusions. The head of the snake, in an octogon of yellow and red stripes in a blue sea, is a direct reference to the Catalan coat-of-arms

Below: the Park's guardian, Python

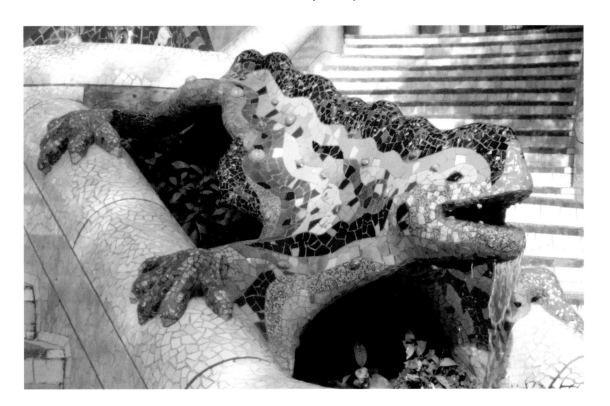

out into Gaudí's amphitheatre. This was planned as the market place, with its gallery of neatly-arranged ochre-coloured rows of Doric columns supporting a roof which is actually the floor for the central square which lies above, encircled by seats. It is these columns through which water that has fallen on the square above drains through to fill the water cistern.

The square, which Gaudí is known to have referred to as his Greek Theatre, measures 78.5 x 36.5m (258 x 120ft); the front half of it looks out towards the sea and is supported on the columns. Here the floor of the square has been designed so that it is not cemented over and is also perfectly flat, thus allowing any rainwater to soak through for collection by numerous pipes which filter the water as it is channeled down through the columns and into the cistern.

The square acts as a playground for small children, a meeting place for young couples and a

Below: the hall of a hundred Doric columns was originally intended and built as a market place, and to act as a support for the public meeting area with its park benches above. The meeting place was also intended to be used as a venue for theatre performances

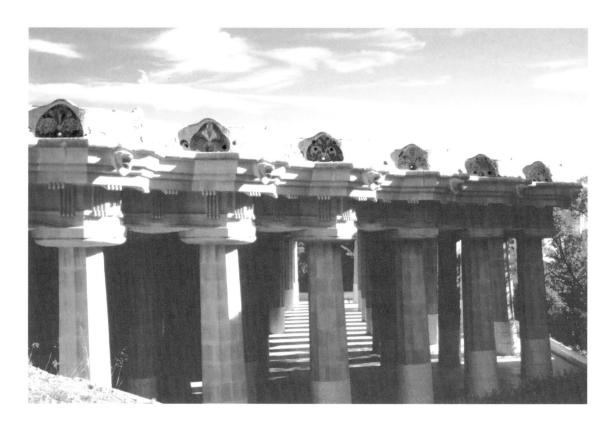

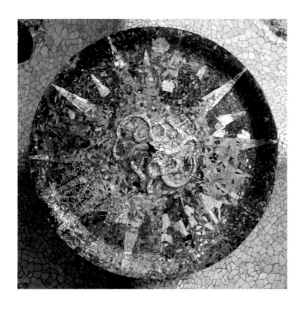

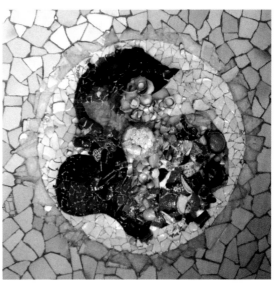

Above: *details of the ceiling trencadís of the hypostyle chamber with its Doric colonnade. Gaudí obtained rejected objects and waste from a number of ceramic workshops, which were broken into useful sizes and then pressed into the mortar when it was still soft. He was helped in arranging these designs by the specialist in such ceramic mosaics, Josep Maria Jujol (1879–1949). Jujol worked with Gaudí between 1904 and 1908 on objects, furniture and iconography. He designed furniture for Casa Batlló, and directed the construction of the chimneys and ventilators of La Pedrera*

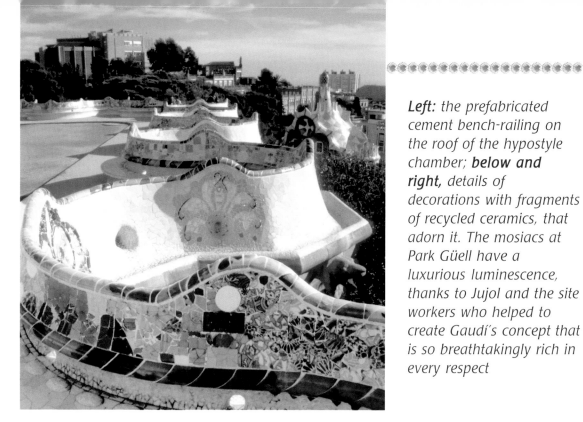

Left: the prefabricated cement bench-railing on the roof of the hypostyle chamber; **below and right,** details of decorations with fragments of recycled ceramics, that adorn it. The mosiacs at Park Güell have a luxurious luminescence, thanks to Jujol and the site workers who helped to create Gaudí's concept that is so breathtakingly rich in every respect

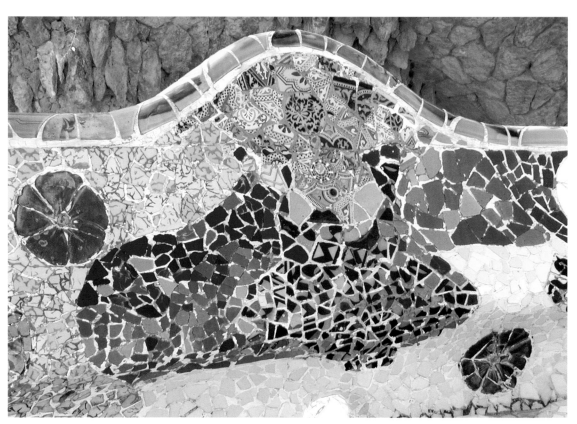

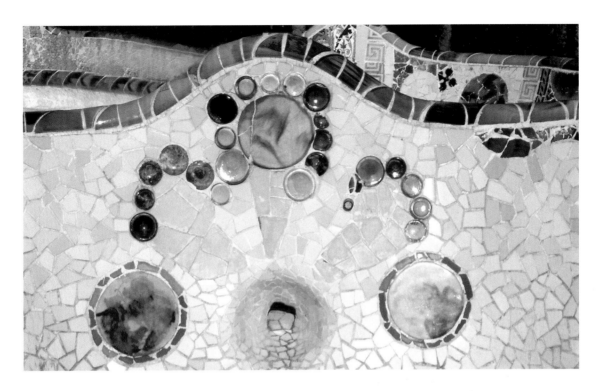

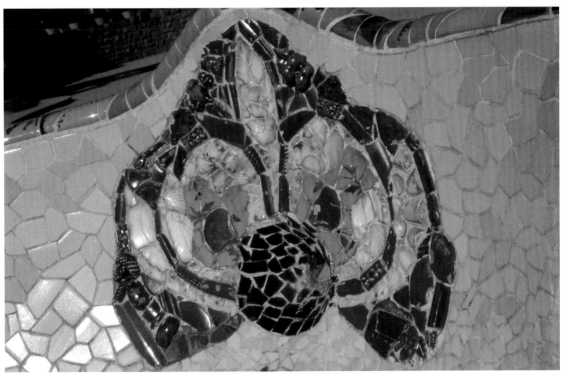

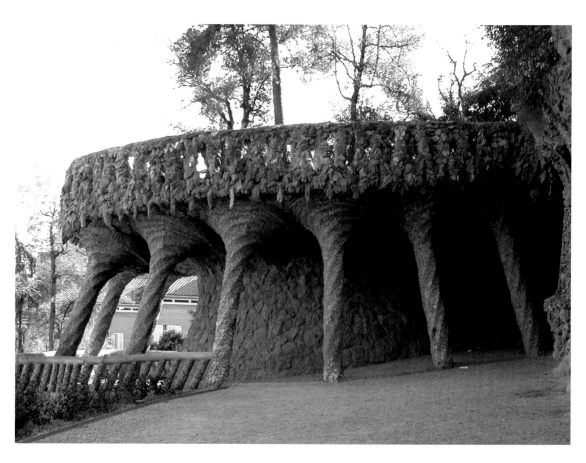

Above, left and right: walkways, bridges, and viaducts with their twisted slanted columns like trees abound. They are like grottoes in a surrealist landscape, where Gaudí followed the dictates of nature in his design instead of carrying out a wholescale flattening of the hills. Pathways are lined with palms, which are mimicked by columns that act as flower baskets; they are traversed by other pathways of arboured columns. The park extends up the hill into a maze of carved passageways, each revealing new illustrations of the forms and personal iconography of a true visionary.

It is here, at the magical Parc Güell, that Gaudí was able to give his craftsmen full rein in realising the captivating enchantment of a fantastical haven from the city street life that belies its immense practicality

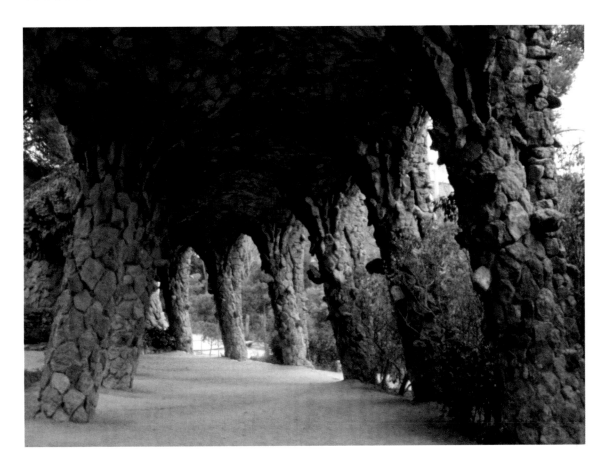

promenade for the elderly. It offers a kaleidoscope of activities for all ages, whether local *habitués* or the multitude of visitors from around the world.

Gaudí modelled the sinuous benches that ring the square on the human form (it is said that he sat a naked man into soft plaster to obtain his mould), and so arranged them to form little niches to facilitate private talk, while also providing an open vestibule in the sun.

The seats are coated in ceramic mosaics, thus providing both a protective barrier against the elements and a joyous riot of colour comprised of thousands upon thousands of broken pieces of coloured tiles and fragments of faïence. Here we see here a tremendous triumph of surface design and a playful untrammelled exploration of natural forms, allied to a sympathetic treatment of the site and a community as client.

*Overleaf: one of the carved passageways at Park Güell with, **inset**, the sculptured face of one of the columns*

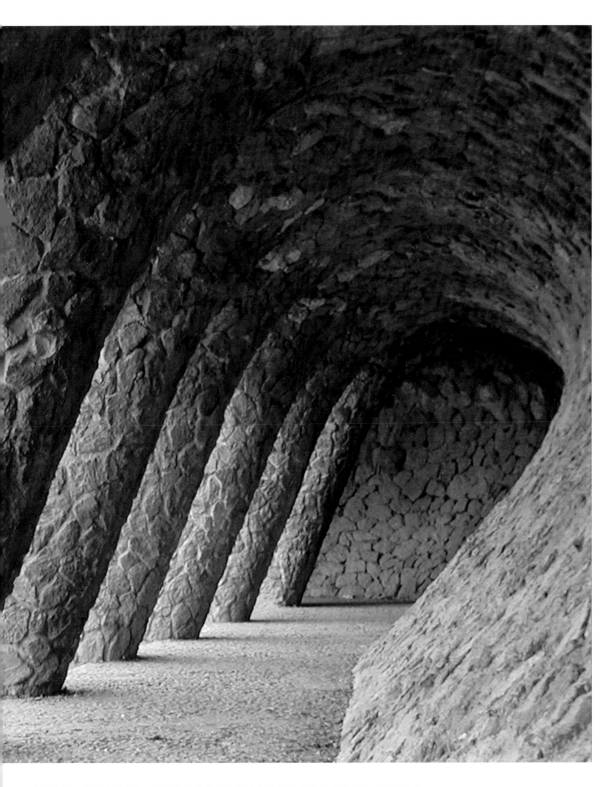

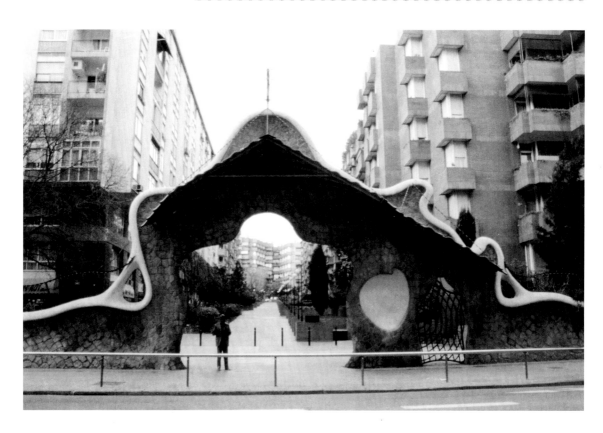

Above: the statue of Gaudí on the pavement in front of the gate is by Joaquín Camps, whose grandfather was the sculptor José María Camps i Arnan, who had worked with Gaudí at the turn of the century

Right: detail of the Miralles pedestrian doorway

Casa Milà which were respectively four and six years in the future, as well as considerably larger projects.

The wall is presented as a stone-based element, with a curvature developed in both horizontal and vertical directions, which thus resembles the writhing movements of a sea serpent. These imaginative contortions are continued over the arch over the gate itself, which was also built as a structure of shapely undulations by Domènech Sugrañes, the whole surreal piece seemingly alive and sinister like an untrustworthy python on the move.

Another of the smaller projects with which Gaudí busied himself at the turn of the century was widely considered as a privileged commission, which involved the design of a group sculpture for the Lliga Espiritual de la Mare de Déu de Monserrat. Known as the First Glorious Secret of the Rosary, it reveals the architect's growing religious distractions and interests.

PALMA
CATHEDRAL

1903–1914

G AUDÍ WAS ALREADY KNOWN for his work on the
Sagrada Familia, and additionally he had been
associated with other ecclesiastical projects,
when he was first introduced to Bishop Campins i
Barceló in 1899. These works included the Palau
Episcopal, Astorga; the Colegio de las Teresianas,
Barcelona, both of which would be built, and the Güell
Colony Church at Santa Coloma de Cervelló, for which
only the crypt would be built. He had travelled to Málaga
and Tangier (1891–92) in order to study a site for a
Franciscan Mission, and although this was not carried
through, his credentials were thus accepted by the
Bishop of Palma, Mallorca, who wanted the interior of
his cathedral to be renovated.

Various proposals from Gaudí fell foul of the
cathedral's Chapter in 1914, and he abandoned the work
to concentrate solely on the Sagrada Familia.

*Left: Gaudí travelled to
Palma in 1902 to study the
site, and drew up plans
which involved moving the
choir stalls closer to the
altar. This had the effect of
clearing the central nave,
leaving it uncluttered for
the use of the worshippers,
while at the same time
giving the impression of
spaciousness. He also
moved the existing
eighteenth-century
baroque altar, which
uncovered an older gothic
altar which had been
consecrated in 1346. He
created this seven-sided
canopy to go above the
altar, the corners
representing the Seven
Gifts of the Holy Spirit*

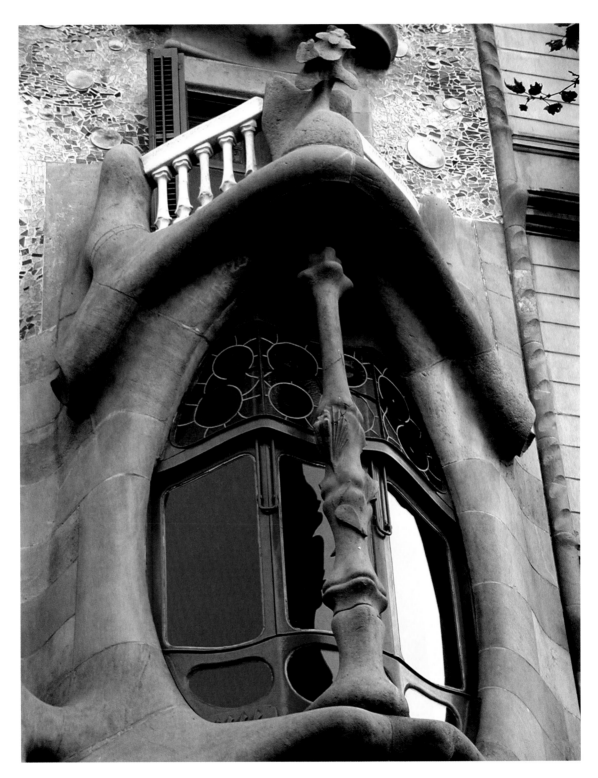

CASA BATLLÓ

1904–1906

JOSEP BATLLÓ I CASANOVAS had been introduced to the architect by Pere Milà, and like other Gaudí patrons, paid for every costly whim of the architect and his vision of paradise. Gaudí is reputed to have described the inner rooms as areas in which 'the corners will disappear and matter will manifest itself abundantly in its astral emphaticness; the sun will enter here from all sides and it will produce an image as though in paradise'. At any rate, Batlló did so until his Castilian wife, with whom the architect was hardly on speaking terms, finally dismissed him with the house still unfinished.

Gaudí only ever built two apartment blocks, and Casa Batlló, Passeig de Gracia 43, Barcelona, was the first. It was originally dubbed the Casa de las Tibias Descarnadas (the house of the emaciated tibiae), because on its lower façade the columns resemble human tibiae, fibulae, vertebrae, collarbones and skulls. More recently and more simply, the block of flats has become known locally as the house of bones. Indeed, the entire building, which had been a conventional block of flats until Batlló commissioned Gaudí to modernise it, is extremely unusual.

The original building had been constructed in

Left: undulations and bones; the façade of Casa Batlló, in the centre of Barcelona

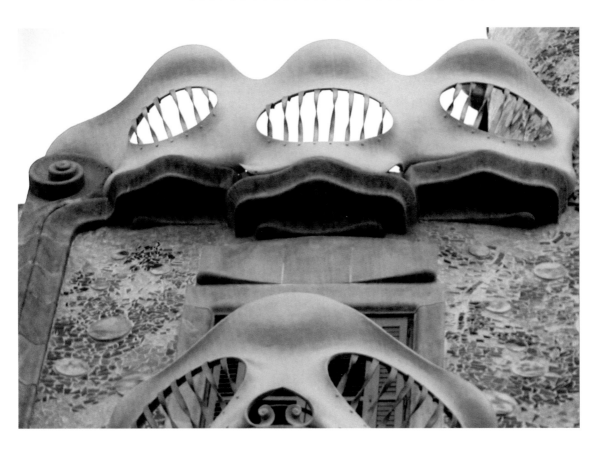

*Previous pages, left: an iron mask shields a window on the street façade, and **above**, on the lower roof where inventive forms play with the mixed background of the façade, elements which evoke a Venetian carnival, though here there are dragons rather than gondolas*

1877, but in 1901 Batlló, who wanted something a bit more prestigious, applied to the city authorities to replace the original building with a completely new one. This never happened as he anticipated, for instead of merely a new building Gaudí provided an utterly unique work of tongue-in-cheek avant-garde art.

The structure, which was built in Montjuic stone, consists of a ground floor plus four further storeys above, and is unquestionably one of the most perfect examples anywhere of what we might call a moulded organic structure. Externally the baroque façade is clad in undulating mosaic, and imitates the skin of a giant reptile, giving us the first clue to Gaudí's reference in the building to St George and the Dragon, a legend to which the architect had already alluded in other buildings, such as the Casa de los Botines.

Iron balustrades in the form of masks cover the

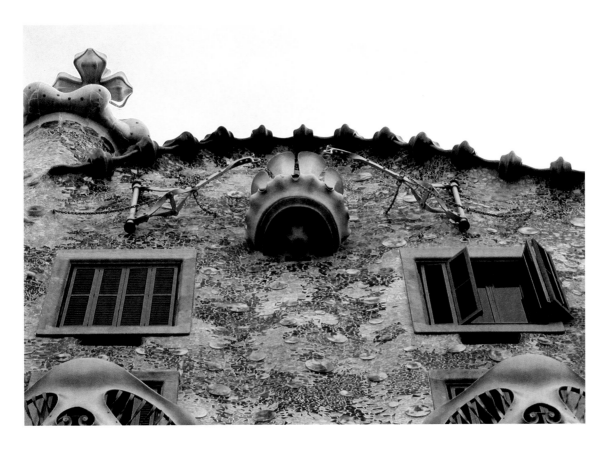

window balconies, while on the roof glazed ceramic tiles are there to remind us of the tail of St George's mythological dragon. Gaudí's roof here is an absolute masterpiece; undulating and sloping, it integrates perfectly with its surroundings, forming a linking element with its adjacent buildings.

Here again, it appears that Gaudí deliberately flouted the city building regulations, unless of course he simply did not appreciate that plans and conditions were to be adhered to. Certainly he appeared only ever to regard any signed and submitted plans as drafts that he was free to tamper with or improve, as he progressed.

He had exceeded the permitted building height at Casa Calvet, and here at Casa Batlló he intruded 60cm (2ft) out onto the pavement with the elephantine feet of his central columns. Although these convey a sense that the house is of truly gigantic proportions, passers-

Above: the dragon's scales cascade down to decorate the façade, while his knobbly spine is silhouetted against the sky, and **overleaf left**, *the roof ridge undulates like the dragon's back; the cross above a rounded turret at the top left of the picture* **above** *is seen in greater detail,* **previous pages right**, *where the ceramic pinnacle, which hides a water tank, rises from the façade's cornice to support the habitual four-armed cross*

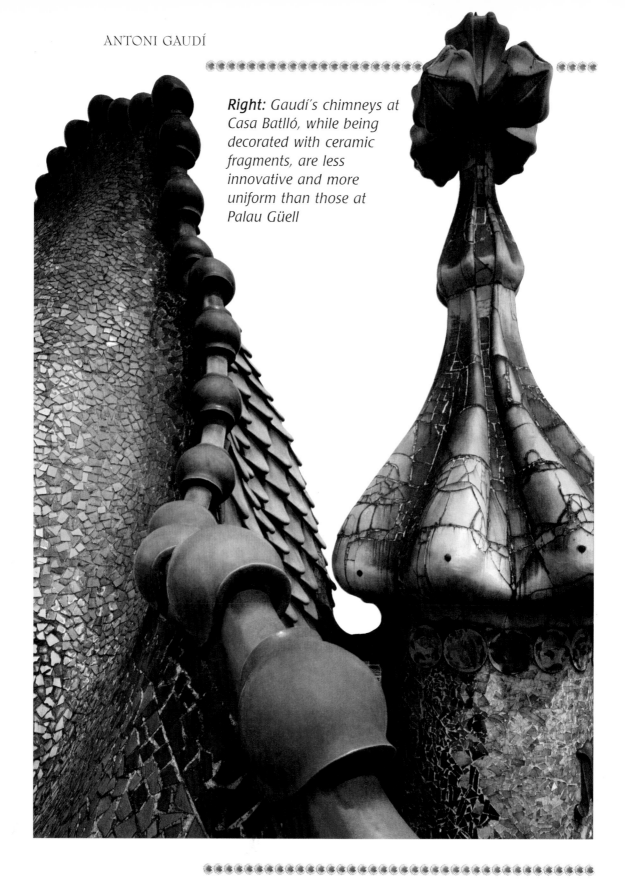

Right: Gaudí's chimneys at Casa Batlló, while being decorated with ceramic fragments, are less innovative and more uniform than those at Palau Güell

Overleaf: a first-floor reception room, provided with a fireplace by which visitors might keep warm. The walls are seemingly plastic, appearing to bend and soar in all directions

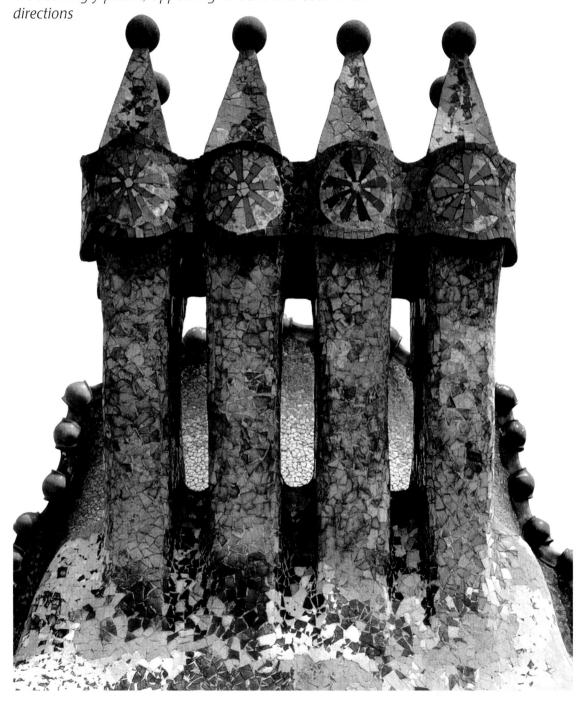

Right, above: the walls around the central patio are clad in blue ceramic tiles, that are coloured darker the higher up they are; conversely, the windows overlooking the patio are larger on the lower floors, where there is less light
Right, below: lighter blue tiles were used internally on the lower floors; this staircase rises from the ground floor

by could bump into and trip over them. In addition to this, the more the building took shape the more the architect was apt to amend and improvise, so that by the time he had departed from the works, Casa Batlló had acquired a mezzanine floor and a couple of rooms in the attic, where he had also introduced a parabolic arch to take the stress of the roof.

Gaudí, who concentrated for the interior on the rooms that were to be occupied by the patron and his family, continued the impression of motion that he had created so successfully on the outer street façade by designing rooms that were completely bereft of straight lines or angles, so that the rooms appear to merge into one another without any sense of isolating divisions.

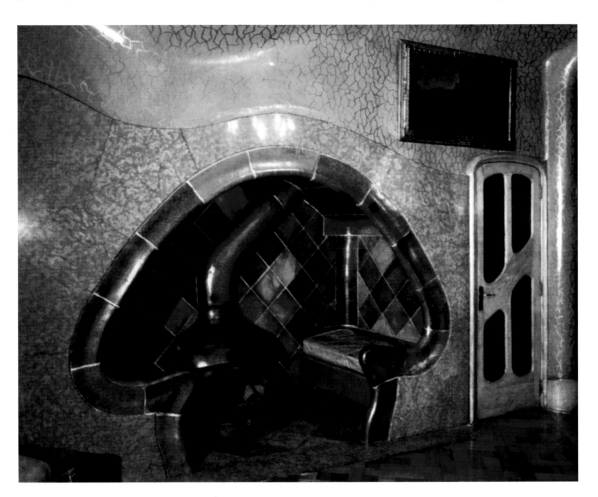

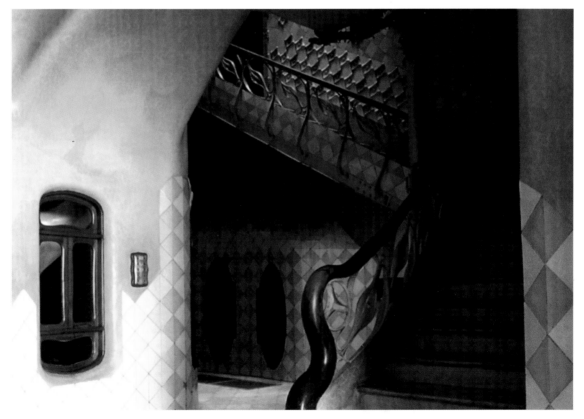

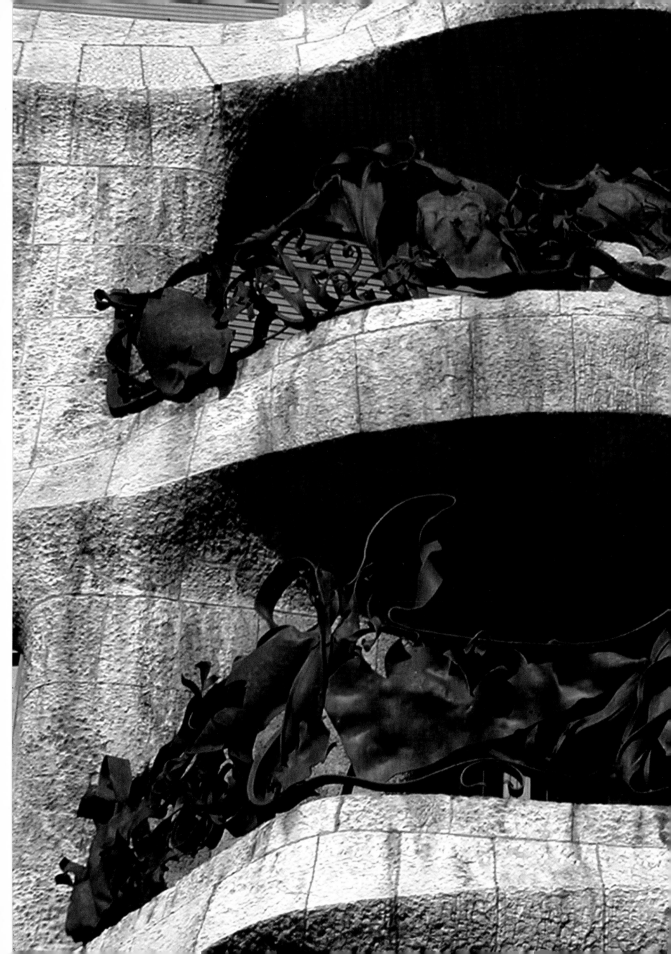

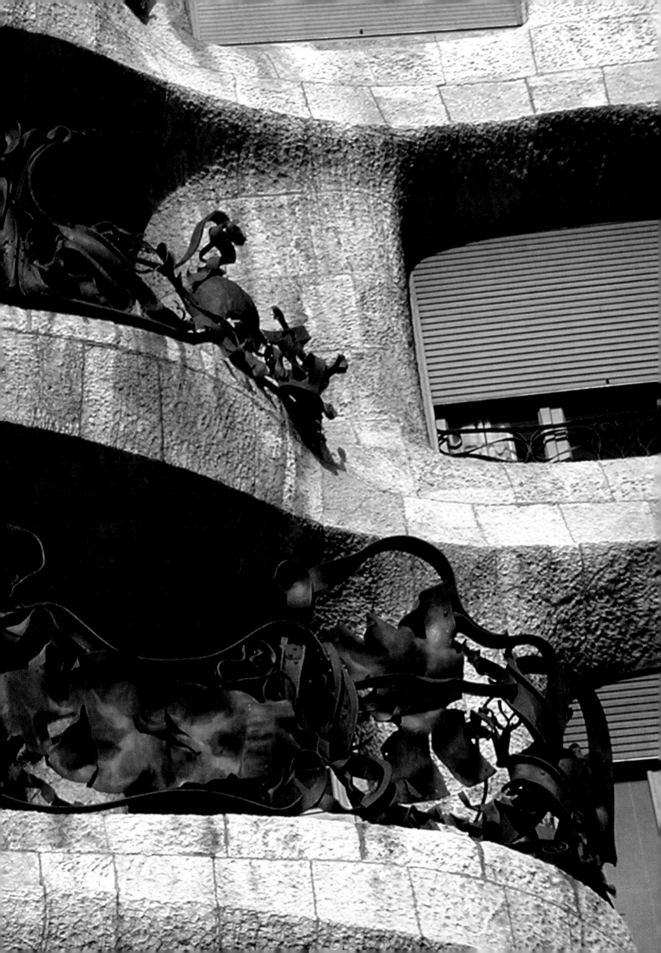

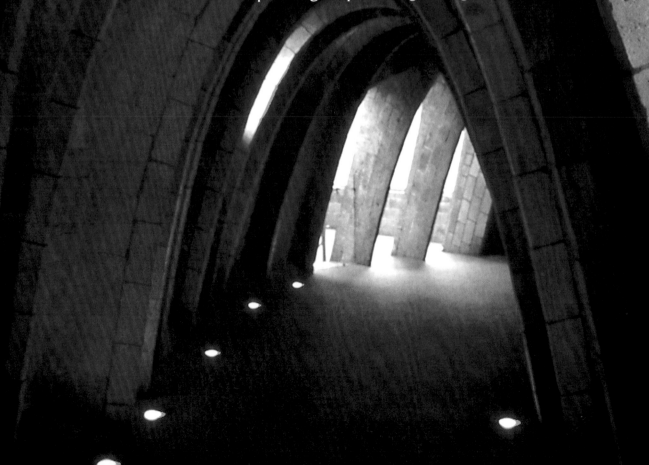

This page: an attic
corridor at La Pedrera

Above right: flat brick
catenary attic arches
provide the vaulting under
the roof terrace

Below right: the stone
façade of La Pedrera, at
Passeig de Gràcia 92,
Barcelona, with its
wrought-iron balcony
balustrades. The design for
each of the external
balconies is unique

However, as usual, Gaudí found it impossible to constrain himself and stay within the budget; the upshot of which was that, when he presented his final bill, the Milàs refused to pay. Gaudí took the matter to court, won the case and with his honour satisfied, donated the money to a convent and never again took on a private commission, diverting all of his energies to his unfinished church.

During its construction, Casa Milà became known for its external appearance by the people of Barcelona as La Pedrera (The Quarry), and the name remains today not only as as a term of endearment but also semi-formally as the identity of the building.

Massive structural columns rise from the ground floor; each has an iron bar as a core, making them highly resistant and able to support by means of this lattice of stone and brick pillars the stone façade from the first floor upwards. This is similar to the construction technique employed for the early American skyscrapers.

The block is constructed around two interior quadrangles, permitting the light to enter the inner-

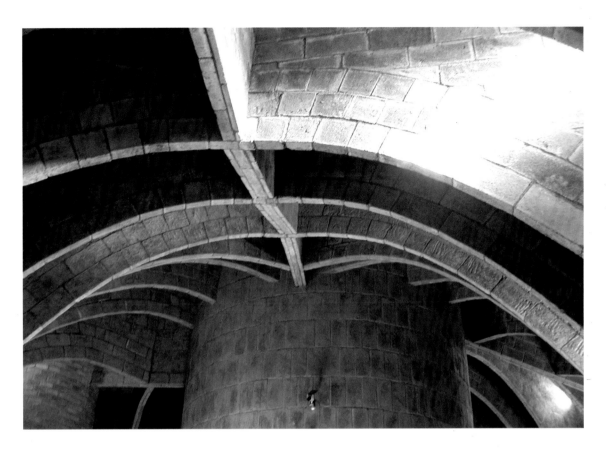

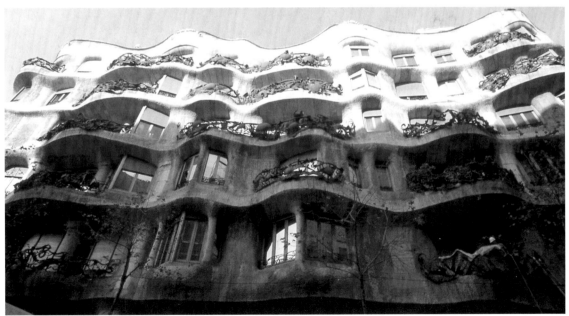

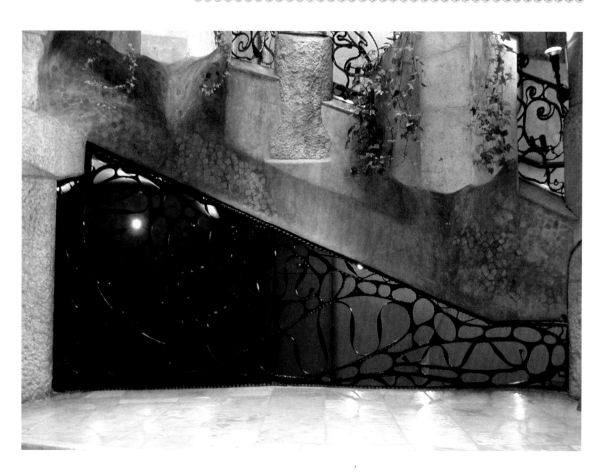

Above: *wrought iron infills beneath the stairs in the main lobby area*

facing areas on all floors of the building. The basement acted as a garage; the Milà family occupied the first-floor rooms, and they rented out the apartments on the remaining floors. Although they were of similar area, these were not so lavishly equipped or decorated. A series of brick-built arches of various types and sizes in the attic served not only to support the roof above but to insulate the floors below. Gaudí's ingenious design produced the circulating draught necessary for the attic, which housed the wash-houses and clothes-drying area.

These loft arches also determined the different levels of the roof above, and it was here that Gaudí excelled by variously crowning the building with skylights, stairwell exits, ventilators and chimneys, all imaginatively sculpted but also forming part of the fabric of the building.

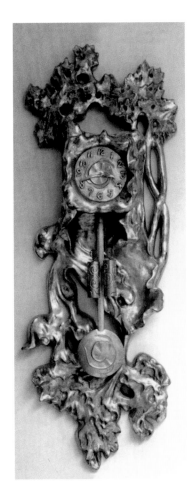

Above: *a wall clock in giltwood, designed by Gaudí in 1909 for Casa Milà*

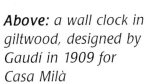

Above right: *brass fittings on a cabinet, now displayed in Casa Milà, along with the ceiling light fitting,* **right**

Right, above: Casa Milà was described in one of his books by Cèsar Martinell, an ex-pupil of Gaudí's, as 'the largest abstract sculpture in existence'. The undulations of the façade were inspired by the Montsant-Serrade Prades mountains that lie 40km (25 miles) to the north of the architect's home town of Reus

Right, below: chimneys, ventilation towers and stairwell exits provide a giddying arrangement of sculptures on the roof terrace. Some are clad in glass, others in marble, and yet more are stuccoed in lime and chalk mortar

The façade of Casa Milà is not quite as exaggerated as that of Casa Batlló in its contorted sinuous naturalistic form, but here Gaudí had a much larger area to work with. For once the architect was not designing within the confines of adjacent buildings or working with a restricted or unalterable site plan, as had been the case for much of his recent building.

This exceptional house, probably the most emblematic modernist building in the city of Barcelona, was constructed with the help of the architect Josep Maria Jujol, the blacksmith Lluís Badia, the Manyach foundation, the plasterer Joan Beltran and the builder Josep Bayó, who all deserve due recognition for the part they played in realising Gaudí's vision.

Gaudí conceived the building as a great sculpture, with the predominance of curved, amorphous, and dynamic forms so characteristic of him, and which here reach their zenith. In achieving this, he tried to avoid both the straight lines which normally define the various floors, and the vertical lines of support between them. What is visible outside is equally manifest internally, where La Pedrera does not have a single straight line or right-angle. Gaudí changed the form of the rooms because of this, designing special furniture to complement them. This allowed the architect to bring to the inside the elements of nature that he designed for the outside, where the walls and the roof are supported by columns that take on the illusion of trees.

The single element that Gaudí was unable to realise was the placing of a huge golden bronze statue of the Virgin Mary on its roof. This idea, rejected by Pere Milà, gave way to a sculpture of a mystic rose below the letter M, for Maria, in a central position at the top of the façade directly above the main entrance along with the inscription 'Ave Gratia Plena Dominus Tecum'. However, the most impressive part of La Pedrera, and once again the most eye-catching, is the flat roof with its protuberant chimneys, ventilators and stair exits, which is now open to the public following its restoration that took place over a ten-year period.

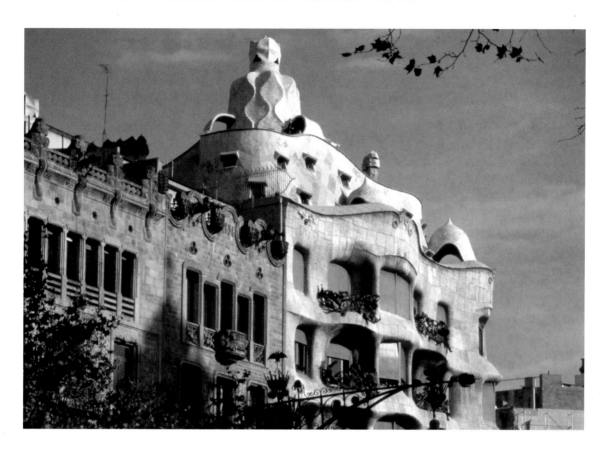

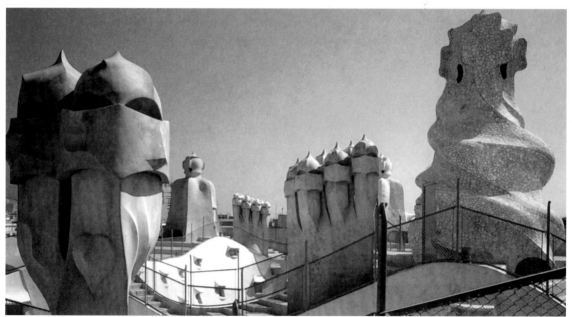

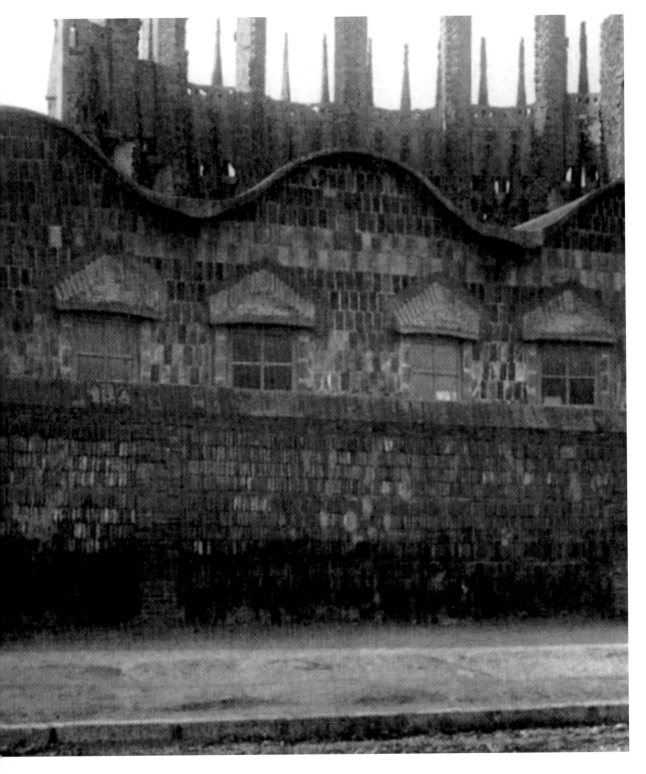

SAGRADA FAMILIA PARISH SCHOOL

1909

ONE OF GAUDÍ'S LAST WORKS, and one of his most perfect, was this small building beside the Sagrada Familia. It encapsulates perfectly the impression of an exaggerated movement in a turbulent wall that seems to unfold, as its small windows highlight the lines and inclinations of the building's light sheet-brick roof and its sinuous vaults. The roof is arranged in such a way that the convexity on one side is mirrored by a concavity on the other.

The school was planned as part of a small complex that was to be built around the Sagrada Familia, and which was to include workshops in addition to school classrooms. However, the Parish School was the only one that was ever erected, yet even in Gaudí's original plans this was to have been demolished once the land was required for the building of the church.

The winding wavy structure has managed to survive; its organically undulating surfaces remain a memorial to the vision of a master architect.

Left: the school in the grounds of the Sagrada Familia was constructed entirely of brick, including the roof, which was in the form of a double conoid

INDEX

A

Alfonso XII, King 17
Andrés, Mariano 89
Apollo 117, 119
architecture, school of, Barcelona (Escola
 Provincial d'Architectura de
 Barcelona) 2, 8, 17, 27
Astorga 79, 80, 89, 133

B

Badia, Lluís 95, 145, 152
 José 145
Barcelona 7, *8*, 9, 10, 11, 13, 18, 20, 22,
 27, 29, 31, 45, 51, 55, 59, 67, 79, 83,
 93, 95, 99, 103, 106, 108, 113, 117,
 119, 133, 135, 145, 148, 152
 Bull ring 145
 Calle Caspe 93
 Calle del Conde del Asalto *see* Calle
 Nou de la Rambla
 Calle les Carolines 31
 Calle Nou de la Rambla 67
 House of 107
 Parc de la Ciutadella 27, 28, *28*, 29
 Passeig de Gracia 135, 145, 148
 Plaza Catalunya 22

school of architecture *see* architecture,
 school of, Barcelona
street lamps
 Passeig de Muralla del Mar 13, *13*, 27
 Plaça Reial *10*, 11, *11*, *26*, 27
Batlló, Casa *see* Casa Batlló
 i Casanovas, Josep 135
Bauhaus 7
Bayó, Josep 152
Bellesguard 102−111, *102−111*, 129
Beltran, Joan 152
Berenguer i Mestres, Francesc 20, 91
Bishop's Palace *see* Palau Episcopal,
 Astorga
Blake, William 97
Bocabella, Joaquima 18
 i Verdaguer, Josep Maria 17, 18, 39

C

Café Pelai 14
Calvet, Pere Màrtir 95, 96
Calvet, Casa *see* Casa Calvet i Pintó,
 Andreu
Campins i Barceló, Bishop 133
Camps, Joaquín 130
 i Arnan, José María 130

Canibell i Masbernat, Eudald 13
Carmel, Mount 85
Carmelite order 85
Casa Batlló 121, 129, 134–143, *134–143*, 152
 Calvet i Pintó, Andreu 92–97, *92–97*, 129, 139
 de los Botines, *88*, 89, 93, 138
 El Capricho 27, 35, 54–57, *54–57*, 59
 Fernández y Andrés *see* de los Botines
 Milà 52, 107, 121, 130, 144–153, *144–153*, *156/157*, 157
 Vicens 27, 30–37, *30–37*, 55, 56, 59, 65
Casas i Bardé 97
Cascante i Colom, Cristófol 55
cathedral *see* Etna cathedral, Palma cathedral
church schools *see* Escoles Pies
Clapés, Aleix 24, 70, 73
Colegio de las Teresianas 29, 50, 65, 82–87, *82–87*, 89, 91, 133
Comella, Esteve 27
Comillas 17, 35, 55
 Marquis of *see* López, Antonio López
Congress of Architects of the Whole Spanish State 22
Cooperativa Obrera Mataronense, Mataró 9, 11, 27, 28, 29, *29*, 91
 workers' houses 10, *10*, 11, 27
Cornet, Antònia 7
Cuba 14

D

de Anasagasti, Teodoro 22
de los Botines, Casa *see* Casa de los Botines
Delphi 117, 119
del Villar, Francesc de Paula 17, 22, 27, 39, 42, 55

de Prades, Margarida 107
de Quijano, Don Máximo Díaz 55

E

Egea, Rosa 11
 i Gaudí, Rosa (Rosita) 12, 19, 20
El Capricho, Casa *see* Casa El Capricho
El Propagador de la Devócion a San José 17
Episcopal Palace *see* Palau Episcopal, Astorga
Escola Provincial d'Architectura de Barcelona *see* architecture, school of, Barcelona
Escoles Pies (church schools) 8
Espai Gaudí 145
Etna cathedral 12

F

Fernández brothers 89
Fernández y Andrés, Casa *see* Casa de los Botines
Finca Miralles 128–131, *128–131*
Fontseré i Mestre, Eduard 12
 Josep 12, 27, 28
Foster, Sir Norman 42
Franciscan Mission residence 29, 133

G

Garraf 17, 18, 55, 56, 69, 91
Gaudí, Francesc 8
 i Serra, Francesc 7, 19, 20
 Museum 19, *19*, 24, 25, *25*
Grau i Vallespinós, Bishop Juan Bautista, 79, 81

These pages: a view of the iron grille that edges the ramp leading to the basement of La Pedrera

Gretel, Hansel and 116
Gropius, Walter 7
Guardiola, Josep 145
Güell, Bodegas *90*, 91
 Colony 20, 99
 Colony Crypt 20, *21*, 98–101, *98–101*,
 133, *158/159*, 159
 Estate (Stables) 18, 27, 29, 56, 58–65,
 58–65, 91, 129
 i Bacigalupi, Eusebi 14, 17, 18, *18*, 19,
 20, 47, 55, 60, 63, 67, 70, 117
 Joan 14, 17
 Palau *16*, 17, 18, *18*, 29, 65, 66–77,
 66–77, 79, 140
 Parc 19, 20, 101, 103, 112–127,
 112–127, 129, 159, *160*
Guimerà, A 12, *12*

H

Havana 14
Hercules 61
Hesperides 61
Homs i Botines, Joan 89
Hospital of the Holy Cross 22

I

Ibarz-Marco, house 24

J

Josephine Associates 17
Jujol, Josep Maria 121, 122, 152

L

Ladon 61
Lamps, street *see* Barcelona
La Pedrera *see* Casa Milà
Lealtad, Masonic lodge 12
León 89, 93
 Plaça de San Marcelo 89
Les Corts de Sarrià 18, 59, 129

Passeig de Manuel Girona 129
López, Antonio López 14, 17
 Isabel 14, 19
loyalty *see* Lealtad, Masonic lodge

LL

Lliga Espirituel de la Mare de Déu de
 Montserrat 130

M

Mackintosh, Charles Rennie 81
Málaga 133
Manyach foundation 152
Manyanet, Father Josep 17
Mare de Déu del Roser 145
Martín I, King of Aragón 103, 107
Martinell, Cèsar 152
Martínez, J B Serra 33
Martorell i Montells, Joan 14, 17, 18, 27,
 39
Mataró 10, 11, 27
Milà, Casa *see* Casa Milà
 i Camps, Pere 135, 145, 148, 151
Miralles, Finca *see* Finca Miralles
 Hermengild 129
Monjuic, mountain 93, 138
Montserrat, monastery 27
Moreu i Fornells, Josefa 11
Morris, William 73
Mutamala, Llorenç 9

N

Neufert, Ernst 7
New York 9

O

Oliveras, Camil 12
Oller, N 12, *12*
Our Lady of the Rose Tree *see* Mare de
 Déu del Roser

P

Pagés, Salvador 9, 10, 11
Palau Episcopal, Astorga, 78–81, *78–81*, 89, 133
 Güell *see* Güell, Palau
Palma cathedral *132*, 133
Panama Canal 145
Pavlovski, Issac Iakovlevich 14
Pedralbes 18
Pedrera, La *see* Casa Milà
Prim, General 8
Puntí, Eudald 9
Pythia 119
Pytho 119
Python 117, *118*, 119, *119*, 159, *160*

R

Reus 7, 8, 9, 81, 145
Riudoms 7, 145
Rosary, First Glorious Secret of the *see*
 Lliga Espirituel de la Mare de Déu de
 Montserrat

S

Sainte-Chapelle, Paris 81
San Felipe Neri 22
San Fernando Academy 79
San José 39
Santa Coloma de Cervelló 20, 99, 133
St Barnabas 22, 48
St George 89, 138, 139
St Ginés 95
St Joseph 101
St Pere Màrtir 95
St Peter 95
St Peter the Apostle, Reus 7
St. Teresa 85
 order of 83
Sagrada Familia, Expiatory Temple of the
 7, 14, *15*, 17, 18, 20, 22, *23*, 24, 29,
 38–53, *38–53*, 55, 69, 101, 133, 155
Parish School *154*, 155
 workshop *6*, 7, 20
Sagués, Doña Maria 103
Scientific Excursions, Catalanist
 Association of 12, *12*, 13
Segimon, Roser 145
Stansted Airport 42
Stiges 17, 55
Subirachs, Josep Maria 14, 51, 52
Sugrañes, Domènech 51, 107, 108, 129, 130

T

Tangiers 29, 133
Tarragona, Archdiocese of 81
Tarrats, Joan 8
Teresian School *see* Colegio de las Teresianas
Tibias Descarnadas, Casa de las *see* Casa
 Batlló
Three Graces, fountain of the 11

U

UNESCO 19, 67, 113, 145

V

van der Veld, Henry 73
Vapor Nou (New Steam company) 8
Verdaguer, N 12, *12*
Vicar-General (Archdiocese of Tarragona)
 see Grau i Vallespinós, Bishop Juan
 Bautista
Vicens, Casa *see* Casa Vicens
 i Montaner, Manuel 11, 31
Vilassar de Mar 95, 96

W

Wharf, Royal 9, *9*

These pages: the crypt of the unfinished church at the Güell Colony
Overleaf: Python, spirit of the Parc Güell

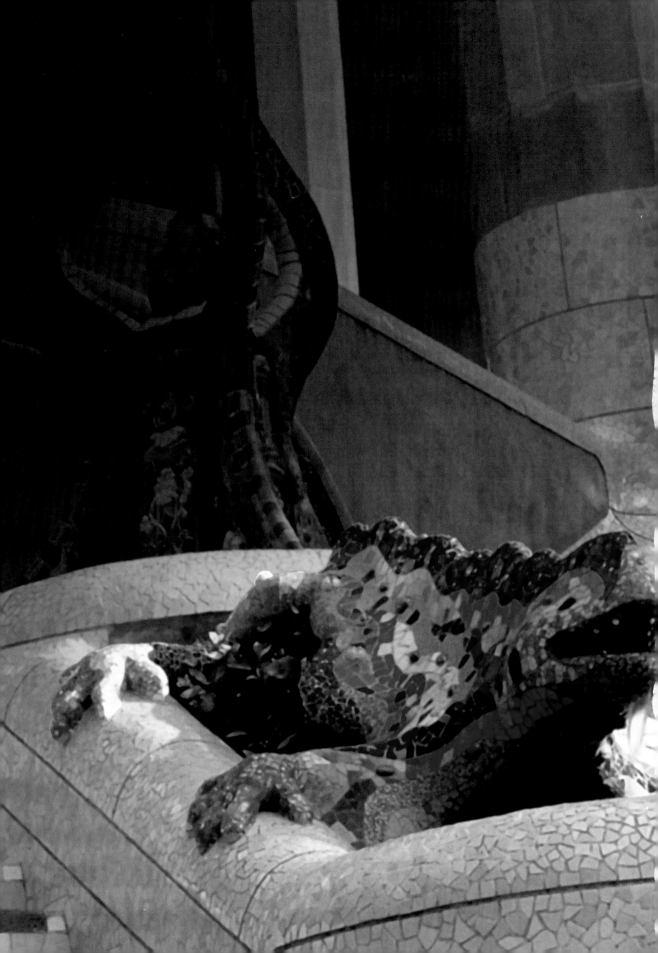